Amphoto Guide to
Flash Photography

Ellis Herwig

AMPHOTO
American Photographic Book Publishing
An Imprint of Watson-Guptill Publications
New York, New York

Photographs, including cover, are by the author, with these exceptions: product illustrations, which were supplied by the manufacturers or their public relations agencies, and historical and other photographs, where another source is given.

Library of Congress Cataloging in Publication Data
Herwig, Ellis.

 Amphoto guide to flash photography.
 (Amphoto guides)

 Bibliography: p.
 Includes index.
 1. Photography, Electronic flash. I. Title.

TR606.H47 778.7′2 81-12829
 AACR2

ISBN 0-8174-3515-8
ISBN 0-8174-3516-6 (pbk.)

Manufactured in the United States of America
1 2 3 4 5 6 7 8 9/86 85 84 83 82 81

OTHER BOOKS IN THE AMPHOTO GUIDE SERIES

Amphoto Guide to Available Light Photography
Amphoto Guide to Backpacking Photography
Amphoto Guide to Basic Photography
Amphoto Guide to Black-and-White Processing and Printing
Amphoto Guide to Cameras
Amphoto Guide to Filters
Amphoto Guide to Framing and Display
Amphoto Guide to Lenses
Amphoto Guide to Lighting
Amphoto Guide to Photographing Models
Amphoto Guide to Selling Photographs: Rates and Rights
Amphoto Guide to SLR Photography
Amphoto Guide to Special Effects
Amphoto Guide to Travel Photography
Amphoto Guide to Wedding Photography

Acknowledgments

Flash has been around long enough to have a lot of books written about it. Whether or not this volume breaks any new ground, it gives me a chance to express my admiration for a chief photographer and a photo staff who have never heard of me: Frank Scherschel and the photographers of *The Milwaukee Journal*, who long ago set a standard of quality in flash photography that I have never seen equaled.

Ed Farber, now a columnist for *Photomethods* and *Popular Photography* magazines, was generous with both encouragement and vintage photographs, as was John Faber of the National Press Photographers Association. Lincoln Russell's illustrations of equipment and techniques made a lot of points more clearly than written words could have done.

The tolerance my wife, Mara Casey, showed to the 10-hour workdays necessary to write a book in two weeks was a major factor in a 40-day production schedule, along with the fast-turnaround editing of Liz Burpee of Amphoto.

Finally, without the long-suffering instruction of Bill Kirby of Mark Gordon Computers, Inc., who taught me how to use my new word processor in less than a week, this book literally could not have been written.

CONTENTS

Some early "convenience" devices for setting light to flash pow-
der looked more suicidal than convenient. The photographer us-
ing this turn-of-the-century flambeau (torch) powder igniter is
Harry Rhodes of Denver, Colorado. The photographer puffed air
into the rubber hose, and flash powder contained in the gadget's
internal chamber was blown into the steadily burning flame.
Burns and more serious injuries were commonplace among flash-
powder photographers. (Photograph, courtesy of John Faber—
National Press Photographers Association)

1

Bottled Sunlight

The rays of old Sol, once an all-important factor in picture making, are no longer essential. ... For capturing the beauties of the landscape we still depend on him, but ... man's ingenuity has supplied a substitute for the sun's rays equally effective and more manageable. For many purposes, in fact, the flashlight is more desirable than sunlight. It can always be depended on to shine when wanted and with just the proper brilliancy; it can always be so placed as to make the shadows fall in the desired direction, and, photographically speaking, it turns night into day. To the amateur bottled sunlight is an especial convenience, for his photographic work is frequently confined to the night time to say nothing of the many times he brings the flashlight into play photographing his friends at evening gatherings. Indeed, it is as a means of photographing one's friends that the flashlight is most commonly used, but the experienced amateur knows of many other ways in which to avail himself of its actinic powers.

This statement is from *Modern Photography*. No, not the present-day magazine but an all-but-forgotten book published in the 1890s by Frederick J. Drake & Co. in Chicago. As is apparent from the excerpt, its chapter on flash photography is as relevant today as it was in its own era. The search for controllable short-exposure lighting is as old as photography itself.

7

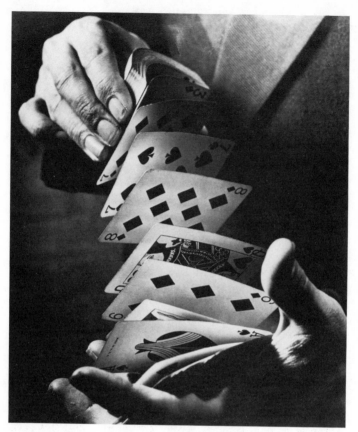

The Milwaukee Journal was one of the first newspapers to make extensive use of electronic flash photography; the staff photographers used equipment designed and built by their colleague Edward Farber. This action shot of riffling cards, made by Ed Farber in 1940, was titled "Apologies to Dr. Edgerton" in recognition of a similar photograph by the pathfinder of electronic photographic lighting. (Photo © Edward Farber)

LIMITATIONS OF DAYLIGHT

The sun was definitely not designed by a photographer. Despite its seeming advantages, it offers virtually none of the features photographers hope to find in their lighting equipment.

It is true that the sun is both available and free (during the daytime, anyhow); but it only shines on some days

and, even then, only in a single, uncontrollable direction. Furthermore, the color of daylight changes constantly according to time of day, atmospheric conditions, and season. The "daylight" for which daylight-balanced color films were designed exists only as a theoretical value. Natural daylight has an endless variety of spectral radiation, which often produces unnatural effects on color films.

It did not take early photographers long to start looking for a more dependable light source, especially since exposures in those days took minutes, even under blazing sunlight, rather than today's fractions of a second.

In 1851, twelve years after he had demonstrated the first photographs on paper, William Henry Fox Talbot, the great photographic pioneer, took the world's first flash photograph. He made use of an earlier discovery made by Sir Charles Wheatstone, a British scientist. Five years before the introduction of photography (1839) Wheatstone had demonstrated the "freezing" of fast-moving objects in a darkened room with the illumination from an electric spark. In a similar way, Talbot fastened a page of The Times to a wheel and set it spinning. Then, by causing an electric spark powered by a battery of wet-cell Leyden jars to jump a gap, he produced a flash bright and short enough (1/100,000 sec.) to form a sharp image of the swiftly rotating newspaper on newly invented "fast" paper emulsion.

The technology wasn't very practical, but the idea was exciting: an action-stopping high-speed flash, having a predictable intensity, which could be placed wherever the photographer chose and fired on command. Talbot himself never regarded his experiment as having serious implications, though. As far as he was concerned, it was only a scientific curiosity. In the mid-nineteenth century, photographic experimentation was more concerned with increasing the sensitivity, or "speed," of photographic emulsions than with perfecting light sources.

THE COMING OF BLITZLICHTPULVER

Then in 1887 (close to the time when Celluloid roll film was patented and also when George Eastman was about to revolutionize the world of photography with the first "Kodak" roll-film cameras) the development of "lightning

powder" was announced by Adolph Miethe and Johannes Gaedicke in Germany—and the era of flash photography began in earnest. This *Blitzlichtpulver* was composed of a highly flammable mixture of powdered magnesium, sodium chlorate, and antimony sulphide. It ignited with a powerful, brief flash of light and was soon being called *flash powder*. Suddenly photographers had a new tool—lighting when they wanted it, where they wanted it.

Jacob Riis's turn-of-the-century flash-powder picture of a little boy caring for his sick mother shows understanding of the limitations of flash lighting. Modern-day users of more evolved hardware can learn from the way he has placed the light so it shines from the far left equally to all elements of the composition and so the cross-light gives a sense of depth, which would have been lost with a flash from camera position. (Photograph, "A Home Nurse," from the Jacob A. Riis Collection, Museum of the City of New York)

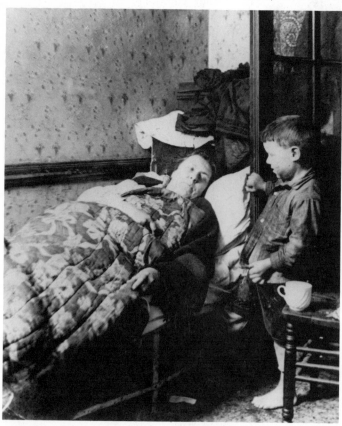

It wasn't long before innovative photographers began to realize the potential of flash powder. In 1888 Jacob Riis, a police reporter, began flash-powder night photography of New York City's slums. *The New York Sun* of February 12, 1888, described his technique under the heading, "Slums and Socialites."

> . . . a mysterious party has lately been startling the town o' nights. Somnolent policemen on the street, denizens of the dives in their dens, tramps and bummers in their so-called lodgings, and all the people of the wild and wonderful variety of New York night life have in their turn been marvelled at and been frightened by the phenomenon. What they saw was a ghostly tripod, three or four figures in the gloom, some weird and uncanny movements, the blinding flash, and they heard the patter of retreating footsteps and the mysterious visitors were gone before they could collect their scattered thoughts and try to find out what it was all about.

Now photographs could be taken where they had never been taken before. While Riis channeled his photographic

In April 1905 Miss Julia Lorillard Edgar was toasted by her bridesmaids before her marriage to Richard H. Williams, Jr. The casual, happy scene was not a casual job to photograph: A Byron Company photographer used a blazing pan of flash powder to record the smiling faces—and the rich furnishings of the room, as well. (Photograph from The Byron Collection, Museum of the City of New York)

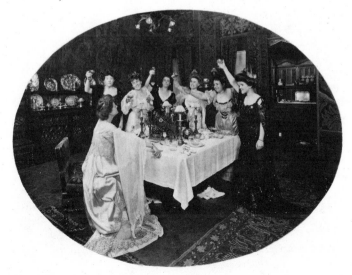

expertise into books for social reform, including his classic *How the Other Half Lives,* the Gay Nineties found other uses for the new flash powder. In that era of expanding American commerce and wealth, fine interior photography of new businesses and homes became both practical and popular. Such New York commercial photographic studios as the Byron Company were kept busy photographing flash-illuminated scenes of stiffly posed employees in shops and factories, as well as of languid society matrons in their Fifth Avenue townhouses.

While flash powder opened up new photographic markets, it was still inconvenient to use. Instantaneous flash shooting, as we know it today, was impossible. Instead, the camera was mounted on a sturdy tripod, the picture was focused and composed, and the subjects were posed. Then a plate-holder was inserted in the camera and flash powder was poured into a horizontal flash pan, the amount depending upon the size of the area being photographed. At last the camera's shutter was opened (or, if there was no shutter, the lens cap was removed) and the powder was detonated by a cap or by a flint-and-steel device incorporated in the pan. There followed a loud bang, a flash of bright light, and a thick cloud of smoke. The technique worked, but it was messy. Few subjects were willing to wait while the photographer took "just one more."

Flash Powder Conveniences

Increased use of flash powder led naturally to convenience-oriented modifications. Originally, the powder was supplied in glass bottles, but soon it was available in different-sized premeasured cartridges. These could be combined as needed, depending on the required intensity of light. For example, when shooting at 10 feet (3 meters) in a room with dark walls and hangings, a photographer would need either two teaspoonfuls of loose powder or a couple of No. 2 powder cartridges; at 15 feet (4.6 meters) he would need either three teaspoonfuls or three cartridges.

For amateur use, flash sheets of magnesium foil were introduced. These were pinned onto a sheet of cardboard facing the subject and ignited with a match for a

one-second to three-second bright-light time exposure. A further variation was a reflector incorporating a clockwork device that kept magnesium ribbon feeding into the reflector as fast as it burned, producing a steady, albeit dangerous, light.

Flash-Powder Dangers

"Dangerous" was the word for flash-powder photography. In view of the capabilities it offered, however, photographic manuals of the period laid stress on prudence: Don't fire powder when the wind is blowing; don't pose portrait subjects facing an open powder flash; keep the powder bottle sealed when firing a flash pan.

Sensational anecdotes about flash powder are legion. Ernie Sisto, long a sports photographer for *The New York Times,* recalls a good one.

> Back about 1928 I was on assignment to meet one of the big incoming liners and get a picture of Henry Ford's son. Well, we all waited around for nearly an hour and the son didn't turn up. Then, out of nowhere, appeared Henry himself, down to meet his son. All the press photographers frantically poured out powder and flashed the picture before our subject got away. Then, hoping to get some better close ups, everybody started reloading their flash powder pans even while they were still warm. I was bending over my camera case getting ready while another photographer was pouring powder from a glass bottle just about five feet in back of me. The next moment the most terrific explosion imaginable occurred. I thought the whole pier had exploded. I fell forward on my face and looked around to see blood running down the face of the unfortunate photographer. In a moment the whole pier was in an uproar with people and cops running everywhere. The exploding glass from the bottle had cut the photographer as well as a number of passengers. One bystander collected $200 damages later for a small glass cut on his nose. Later I found that a big chunk of the bottle was embedded in my back. However, I didn't get a cent for that. (Quoted in *Synchroflash Photography,* [New York: Morgan & Lester, Publishers, 1939], page 3.)

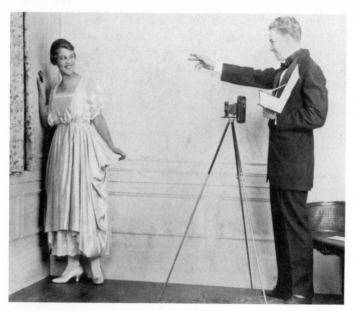

The photographer holds an asbestos-coated fold-out frame containing a sheet of magnesium foil. The sheet will be ignited through a hole in the back of the frame. The lady is smiling; she may feel different after facing what amounts to a hand-held explosion. Flash sheets were safer and more convenient than flash powder, but they were still a clumsy and dangerous way to produce light for photography. (1917 photograph, courtesy of Eastman Kodak Company)

Commercial photographers used flash powder, too, and faced similar dangers. Lejaren á Hiller, a pioneer photographic illustrator, tells of his experiences shooting a color magazine cover photograph before 1914. He was using the clumsy Hess Hi-Cro camera. The subjects were a baseball player and his girl, the latter dressed in a "screaming red" dress.

> At high noon we got the models in place on the roof of my studio. Between them and the background I placed a flash pan holding four ounces of magnesium powder; on both sides of them a little farther away, six ounces each, and above the camera another six ounces. All were wired to go off simultaneously. Having given the proper warnings I got the models together in a tender embrace and let 'er fly. It wasn't that anyone was hurt, but we had a little trouble to find our things—the background

for instance. Across the street the members of the Lambs Club were hanging out of their windows and likewise the transients of the Bellmore Hotel next door. I managed to grab the end of the tripod while the camera was hopping away, so everything was hunky-dory. I sent the separation negatives to Mr. Hess with dispatch and in the course of time received the finished print with the suggestion that I use a trifle more light.
(Quoted by Louis Walton Sipley in *A Half Century of Color* [New York: Macmillan, 1951], pp. 54-55.)

Such spectacular flash powder applications pointed up both the good and the bad aspects of the technique: It supplied incredible amounts of light, but in many situations it was too dangerous. Film speeds of the day were slow—an ASA speed of 12 (12^0 DIN—ISO $12/12^0$) was considered fast. Although high output lighting equipment was called for, flash powder wasn't the answer.

THE COMING OF THE FLASH BULB

Then Johannes Ostermeier marketed the world's first flash bulbs. They were manufactured by the Vacublitz Company in Germany in 1929. General Electric began American production in September 1930.

Instead of being in an exposed pan, the combustion providing the light was sealed in a seven-inch-high glass envelope that contained aluminum foil in a pure oxygen atmosphere. The foil was ignited electrically by the current from a flashlight whose reflector had been removed, the big bulb having been provided with an incongruously tiny flashlight-bulb screw base in order to make the contact possible.

Under most conditions, these bulbs could be used with relative safety. The first bulbs had their problems, however. They were dangerously sensitive to static electricity. If, on a dry day, a photographer withdrew a bulb from its paper storage sleeve too quickly, the bulb would go off. For this reason it soon became standard procedure to hold bulbs only by the metal base, even after safety coating was introduced in 1938. Then, too, bulbs sometimes shattered when fired, showering subjects with sharp fragments of hot glass.

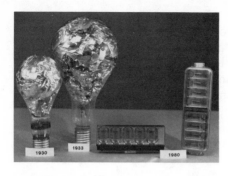

Fifty years of flashbulbs produced these General Electric classics: the GE No. 20, GE No. 50, Flashbar, and Flipflash.

All the same, the potential of flash bulbs was enormous. Their convenience was immediately appreciated by news photographers, who began custom-making electrical and mechanical synchronizers. These devices coordinated the bulb's ignition with the opening of the shutter, making flash exposures at high shutter speeds practical. Open-shutter techniques, which had restricted the use of flash powder to stationary subjects, gave way to *synchroflash*, which allowed the photographer to capture moving objects or images.

The first synchronizers were used with the front leaf shutter of the then-standard 4 × 5 Speed Graphic at its top speed of 1/200 sec. But the development of "longpeak" bulbs, designed for use with the Graphics' high-speed focal-plane shutter, soon made feasible "speedflash" exposures of 1/1000 sec. A wide selection of synchronizers, adaptable to virtually all cameras, was on the market by the late 1930s.

The early foil-filled flashbulbs were a great improvement over open-powder flash. Firing of the bulb could even be mechanically synchronized with the shutter's opening, as is shown here: When the shutter is tripped, the cocking lever of this mid-1930s Speed Graphic's Compur shutter will brush across two exposed contacts on a synchronizer mounted on the lens board, closing the circuit and firing the bulb. (Photo, courtesy of John Faber—National Press Photographers Association)

Flash bulbs became a hallmark of the Thirties and Forties, a great growth period in the history of photography. Anyone could get good flash pictures with some basic instructions. Synchronizers capable of firing several bulbs simultaneously permitted multiple-source lighting effects of studios quality to be made on location. It was no longer necessary to carry along hundreds of pounds of hot, heavy-voltage incandescent lights. Barbara Morgan, whose action-stopping photographs of Martha Graham's modern dancers have become classics, described the difference such lighting made for her.

> With synchroflash I can illuminate what I want and no more. At will I can create zones of importance by dominant and subordinate lighting. I can impart sculptural volume or flat rendering to the same subject. By controlling direction and intensity I can launch light as a dynamic partner of dance action, propelling, restraining and qualifying. Light is the shape and play of my thought, my reason for being a photographer.
> (Quoted in *Graphic-Graflex Photography*, by Willard D. Morgan and Henry M. Lester, 8th ed. [New York: 1948, Morgan & Lester], p. 218.)

Flash Bulb Benefits and Liabilities

In the early Thirties, when color photography was becoming big business for a fortunate few, massed flash bulbs gave photographers the ability to illuminate large areas effectively despite the clumsy color techniques available. More than a thousand flash bulbs were sometimes used for a single exposure. Magnificent results were obtainable, as is witnessed by the series of illustrations made by Anton Bruehl for *Vanity Fair*, the great prestige magazine of the day.

In 1935 alone, General Electric sold 3,688,000 flash bulbs; it was the high point of the early flash era. But although they were a big improvement over the open pan of flash powder, bulbs still had problems.

• They could only be fired once. Flash photographers found themselves weighed down with a bulky yet fragile load. Flash bulbs were available in different

strengths by the middle Thirties, and multiple-flash users often needed to carry many in each of several sizes. There was the added difficulty of disposing of them after use. When Margaret Bourke-White traveled to Russia for *Life* magazine in 1941, she took 5000 bulbs with her!

• The color of flash-bulb illumination, while consistent, was a color all its own. It did not match the color balances of the color-film emulsions then being made. There were, indeed, flash bulbs with a blue coating to adapt them for use with daylight color films; but they lost as much as half their light output as a result of the coating.

• Flash bulbs do not give their brightest output at the instant of ignition; they need about 20 milliseconds to reach maximum brightness. Each synchronizer design incorporates an adjustment to match this brief time lag to the performance of a particular shutter. In the early days, this adjustment was delicate; it had to be set with precision and rechecked frequently. Everyday use of the equipment could knock the adjustment out of kilter and result in disastrous underexposure.

• The faster the shutter speed used with synchronized flash bulbs, the less of the bulb's power was actually being used. While the full duration of a flash was a fortieth of a second, only a fraction of that intensity was used when the camera's shutter was closing after 1/200 sec., 1/400 sec., or 1/1000 sec. The rest of the light was wasted. Photographers taking action pictures at high shutter speeds on slow color film frequently had to resort to multibulb setups to be sure of enough light.

Clearly, times were getting ripe for another invention.

HOW TO "STOP" ACTION

In 1931 Dr. Harold E. Edgerton and his partner, Kenneth J. Germeshausen, of the Massachusetts Institute of Technology in Cambridge, tested the first "electronic" flash.

Releasing high-voltage electricity through a glass tube filled with inert xenon gas, they caused the gas to ionize momentarily with a bright, short-duration flash. The tube could be reused, and both the intensity and duration

of the flash could be controlled by means of the electrical input. Flashes as short as one millionth of a second were now possible.

The high-speed photography made possible by this equipment was not entirely new on the photographic scene. By the late nineteenth century, electric-spark photography similar to Talbot's 1851 demonstration had been greatly refined. Professor Ernst Mach of Prague University and Dr. P. Salcher of the Naval College at Fiume (now the city of Rijeka, Yugoslavia) succeeded independently in producing photographs of bullets moving at speeds of 765 m.p.h. in 1885–86. In 1891 Lord Rayleigh, the British scientist, produced a similar high-speed photograph of a soap bubble at the moment of bursting, and the beginning of the twentieth century saw Dr. Lucien Bull producing sharp spark photographs of the rapid movement of insect wings.

The earlier electric-spark photographs did not produce photographs as we know them. In fact, a camera was not even used: The single spark threw the shadow of the subject onto a photographic plate. The whole procedure took place in a dark room. Special triggering equipment coordinated the spark with the object being photographed. The technique was classic and, in fact, is still used in many industrial applications.

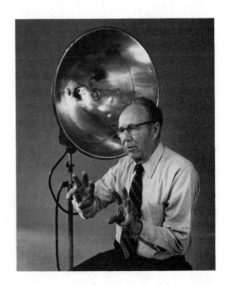

"Papa Flash," Dr. Harold Edgerton, discusses details of the 50,000-watt-second electronic flash unit (background) he and his staff designed for night aerial photography during World War II. Airborne electronic flash photographs supplied important information for many Allied plans, including the 1944 Normandy invasion. (1978 photograph)

The search for high-speed photography was world-wide. The pioneering photographs of splashes made by Lord Rayleigh and Prof. A.M. Worthington in England and the experiments of Dr. Bull in France and Théodore Lullin in Switzerland laid the basis for the work of Edgerton and Germeshausen.

Exploring New Capabilities

Edgerton and Germeshausen's first application of their flash system was not for photography at all. Rather, it was intended for the inspection of moving machine components using the "stroboscopic principle": An electronic flash tube was adjusted to wink rapidly, at a speed coordinated to the spinning rate of the machine component, in a

Dr. Harold Edgerton's 1936 photograph of the crownlike splash of a milk drop is probably the most famous picture in the history of high-speed photography. Shot using a flash duration of 1/10,000 sec. (Photo, courtesy of the M.I.T. Press)

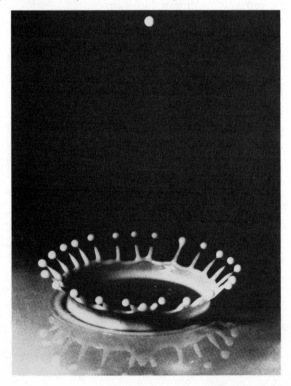

dark room. Because of the human eye's persistence of vision (the same capability that makes motion pictures appear to move, when in actuality what we see is a series of still pictures flashed on the screen one after the other), the moving subject would seem to stand still and could be examined for defects. From this semirelated application, incidentally, comes the common shorthand term for electronic flash, *strobe*.

Edgerton and Germeshausen soon realized that the winking stroboscopic flash had other uses. It could also be made to produce a series of multiple-exposure photographs showing the components of a particular motion—a golf swing, a ballet jump, a badminton serve—as overlapping images whose frequency depended on the rate of the flash (100 per second was common for most human movements). Furthermore, stroboscopic photography produced images that were visually fascinating as well as functional.

It soon became obvious that the benefits of electronic flash extended beyond its stroboscopic applications. Used in a single-flash configuration, it seemed like the perfect photographic light source. Unlike one-shot flash bulbs, the xenon tube could be used for thousands of flashes. The short-flash duration guaranteed sharp pictures.

An additional benefit of the electronic flash was a color similar to daylight. Photographers could therefore use it with daylight-balanced color film. And because electronic flash (also referred to as "speedlight") reached full power the instant it fired, the need for synchronization-delay adjustments was eliminated. Since the brief flash was faster than the operation of any camera shutter, high shutter speeds did not decrease the flash's effective intensity.

Not content with developing this photographic boon, "Doc" Edgerton publicized it with an eye for visual spectaculars. He and his MIT associates produced a series of photographs that would have been impossible without speedlights. Sheets of glass shattering under a bullet's impact were frozen into immobility at a millionth of a second; a balloon was seen on film half-deflated as a bullet passed through it; a football, squashed by a kicker's toe, was caught by the new flash. The crownlike splash of a

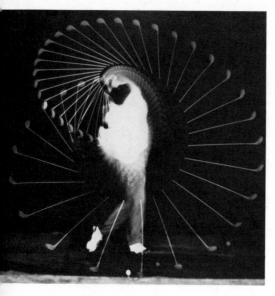

"Densmore Shute Bending the Shaft"— this motion study made possible by stroboscopic electronic flash was a revelation when it was taken in the late 1930s by Dr. Edgerton. In a darkened room, the golfer swung a club in front of a camera with an open shutter. The stroboscopic light flashed 120 times per second. Each flash caught the club in a different position. (Photo, courtesy of the M.I.T. Press)

drop of milk on a tabletop became Edgerton's most famous picture.

Realizing that the action-stopping qualities of speedlight would be particularly attractive to photographers of fast-moving subjects, Edgerton began supplying equipment to several prominent sports photographers. In 1940 Joe Costa took a classic speedlight picture for The New York Daily News—snarling Joe Louis landing a punch on his opponent's jaw. The picture was published worldwide without identification of the lighting technique used. Rather than being offended, Edgerton felt that this omission signified the acceptance of his flash as a standard photographic tool too ordinary for mention.

Also in 1940 the first electronic flash units available commercially were marketed by Eastman Kodak, under the name "Kodatron," for studio use. The next year Ed Farber, photographer at The Milwaukee Journal, marketed his Lee Strobo Speedlamp portable flash unit as an assemble-it-yourself kit.

The first portable flash units came on the market shortly after the end of World War II. They were impressive more for their potential than for their ease of operation. The usual configuration was a power pack and a camera-mounted lamp head. The power pack was con-

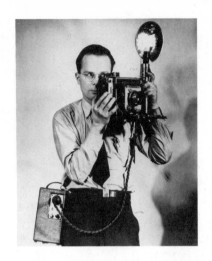

Edward Farber was one of the earliest boosters of electronic flash equipment. While a staff photographer on The Milwaukee Journal in the early 1940s, he designed and built both portable and studio units for staff use and for sale to the public. (Photograph, courtesy of Edward Farber)

nected by a stiff and heavy high-voltage cord to the head, which contained the flash tube and reflector—often a sealed-beam affair similar to an auto headlight. The shoulder-carried power pack included a wet-cell battery and the capacitors that built up the high voltage necessary to produce a flash. Since the early capacitors were oil-filled metal cans, the power pack usually weighed more than 15 pounds; early speedlight photographers had a characteristic stoop!

In the early days, operation could be exasperating. The low-voltage wet-cell battery often needed more than 15–20 seconds to recycle, or build up a full charge in the capacitor. The flash was extremely short—often 1/10,000 sec.—and this often caused reciprocity failure, a loss of film speed that is due to exposures too short for the emulsion's chemical capability. It also turned out that electronic flash tubes had a high content of ultraviolet light, which gave a bluish cast to color photographs. And few cameras were as yet equipped with the nondelay "X" synchronication necessary for electronic flash.

But the advantages of electronic flash gave impetus to the solution of these problems. By the late Forties the new flash's popularity had grown so quickly that some flash-bulb manufacturers began offering electronic units of their own. Flash durations were lengthened to the point where normal response could be expected from color films. Filters made it possible to counteract the UV output

of the flash tubes. High-voltage dry-cell power packs with compact dimensions and two-second recycle times were introduced by several manufacturers, much to the delight of news photographers. The smaller speedlights combined a self-contained power source, capacitors, a tube, and a reflector in a single unit small enough to be mounted on a camera.

Automatic Exposure Control

In 1967 came the biggest news in speedlights since Dr. Edgerton's original invention—automatic-exposure flash. No longer did photographers need to change the *f*-stops on their lenses to get correct speedlight exposures at various distances. All that was necessary was to set a single *f*-stop, depending on the speed of the film being used. As long as the photographer kept within the distance range of the flash unit's automatic exposure capabilities, exposure calculations would be made instantly and automatically by the unit itself.

In the early 1970s an additional refinement, thyristor circuitry, made automatic-exposure flash units even more desirable by adding a power-saving feature: If the unit's capacitor was not fully emptied by the needs of a particular exposure, the unused power was retained in the capacitor. As a result, recycling time was shortened and there was less battery drain, giving the potential for more flashes per battery or battery charge. (There will be more about this in Chapter 2, "How Electronic Flash Units Work".) In the expanding world of portable electronic flash units, the combination of automatic exposure and thyristor circuitry has become widespread. Today, the two terms have been merged into one, *auto-thyristor* (or AT).

TODAY: HEYDAY OF ELECTRONIC FLASH

Portable electronic flash is enjoying a boom just as impressive as was the flash-bulb boom of the mid-1930s. Camera manufacturers are joining in the game with what are called "dedicated" flash units. These are auto-thyristor devices designed for use with a particular camera. Special-

24

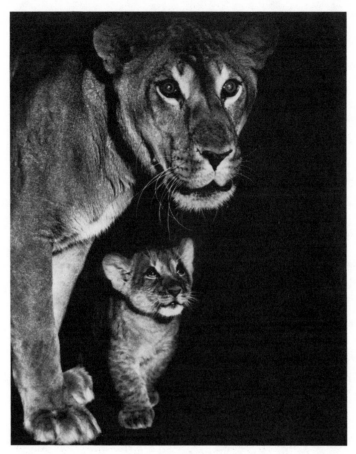

In the summer of 1941, The Milwaukee Journal sent Hugo Gorski out on assignment with the then-unique 13-lb (5.9 kilogram) portable electronic flash unit. The resulting lion portrait, titled "You Tell 'Em, Ma!", was later described by Eduard Steichen as "a truly champion animal picture."

ized contacts mate with the host camera and, as the unit is inserted into the camera's flash-mounting shoe, the "X" synchronization and correct *f*-stop are set automatically. Some dedicated units offer a special fast-recycle setting for sequence shooting with motor drives and automatic winders. The latest dedicated flash refinement uses the camera's through-the-lens (TTL) exposure system to meter flash exposures, as well.

Limitations of Electronic Flash

While this book will tell you about the many advantages of and uses for portable electronic flash, you should realize from the start that flash will not do everything. Like all tools, it has its limitations.

• All flash equipment, whether using flash bulb or electronic tube, offers a finite amount of light. If it isn't enough, you will need either more lamps or bigger ones (or faster film). You cannot make time exposures with flash the way you can with such constant-light sources as daylight or incandescent lamps.

• Electronic flash does not always adapt to the mechanical limitations of focal-plane shutters such as those used on most 35mm single-lens reflex cameras (SLRs). It will only synchronize correctly at relatively low shutter speeds, never faster than 1/125 sec. and more often only up to 1/60 sec. If a faster shutter speed is used, the frame will only be exposed over part of its area.

• An electronic flash unit is one more object to buy, maintain, and carry around. Batteries can go dead; circuits can go wrong for no apparent reason. If you don't use it very often, it's easy to forget the unit the one time you do need it.

• During that brief flash of light, especially if you're using an SLR (whose mirror will be up during the moment of exposure), you're not likely to see the actual effect of the light. In fact, you may not even know whether the unit has gone off at all! Flash units aren't like constant-light sources that let you see exactly what you're going to get.

But knowing what a piece of equipment *cannot* do is the first step toward understanding what it *can* do. This book will help you make the most of portable flash, from buying a unit to evaluating the results in the pictures you make with it.

Portable flash cannot do everything, but what it does do, it does very well indeed. It's as close as we're going to get to a bottle of sunshine.

2

How Electronic Flash Units Work

If you've ever tried the old practical joke of filling a bucket with water, balancing it on top of a door, and waiting for someone to nudge the door and bring the water cascading down, you've also demonstrated the basic principle of electronic flash power.

The analogy is simplified, but it does include a basic fuel (in place of electricity, the water); the principle of capacitor charging (filling the bucket slowly and emptying it quickly); the trigger circuit (the balancing of the bucket on top of the door); and the actual firing of the unit (nudging the door slightly, which upsets the balance and brings the water down all at once). Electronic flash operation is of course more refined than this, but the result is comparable: Current is slowly built up to a high voltage and a slight electrical nudge dumps the power into the flash tube; this cascade of volts causes ionization, which produces the flash itself.

BASIC CIRCUITRY

The battery current of most portable electronic flash units is low-voltage direct current (DC), which passes into an *oscillator*, emerging as alternating current (AC). The low-voltage AC passes into a *step-up transformer* that converts it into high-voltage alternating current, which then must

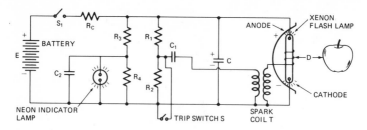

This schematic drawing shows the circuit of a direct triggered flash unit. Power comes from the battery. When the switch is closed, the flash surge begins. (Drawing by Vantage Art)

be converted back into direct current by a *rectifier circuit.* This now-high-voltage DC is fed into the capacitor, where it builds up to the voltage necessary to produce ionization in the flash tube the capacitor is connected to. This buildup occurs over a variable period of time—the recycle time—which depends on capacitor design and size as well as on the incoming voltage. The capacitor can take anywhere from a fraction of a second to 15 seconds or more to reach this necessary voltage.

Kicking the Electrical Bucket

The camera-connected portable electronic device with its capacitor fully recycled is like the full bucket balanced on top of the door: The electricity from the capacitor is actually running through the flash tube, but it needs a bit of a nudge before ionization can take place. This is the job of the synchronization trigger circuit.

Wrapped around the flash tube is the *trigger coil,* which consists of either a wire or a strip of electrically conductive paint. This coil is connected to the *trigger circuit,* which takes a bit of low-voltage current from the electrical system of the unit. Via the "sync cord" (*synchronization cord*) running between the unit and the camera (or via a direct unit-to-camera *hot shoe* connection) the trigger circuit mates with the camera's synchronization circuit.

When the camera's shutter-release is pushed, the trigger circuit is closed and the trigger coil around the flash tube in the speedlight unit disturbs the delicate bal-

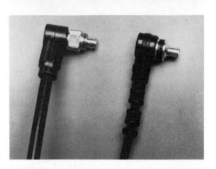

The weakest link in electronic flash operation is a PC cord that pops out of the sync plug. One solution is a threaded sync socket like the one at the right. The cords are easy to tell apart (below): The threaded PC cord tip is on the left and the common push-on plug, on the right.

ance of the flash tube's gas and the capacitor's voltage. The result is a bright flash of ionized gas.

How important is it for you to understand all this? Not very. All that is important for you is to understand the ways in which electronic-flash technology affects the results you can expect from your speedlight unit.

• The recycle time determines how quickly you can take pictures. In a fast-moving, eventful photographic situation, the longer the recycle time, the fewer the pictures you will have time for.

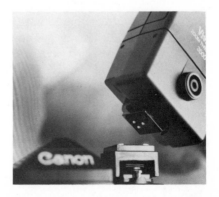

When the contact pins of this Vivitar flash unit mate with the contacts of the camera it is being mounted on, the unit becomes "dedicated" to that camera. Availability of a line of interchangeable dedicated contacts makes it usable with different brands of cameras.

• The power of the unit determines how much light you will have available. The greater the volume of the capacitor and the greater the capability of the flash tube, the more light you can use. Understanding how to relate this output to the other factors that determine correct exposure (film speed and background or surroundings) is the key to correct use of your portable light.

MEASUREMENTS OF POWER

How is a flash lamp's power expressed? Aside from the automatic-exposure and auto-thyristor units the advertisers tell you about (we'll return to them later) you may come across one or more of the criteria that follow.

Beam Candle Power Seconds (BCPS for short). This is a physicist's way of telling you how much light is emitted by the flash tube of a particular flash unit. It is reasonable, as far as it goes; the trouble comes when we consider the other factors affecting useful light output, and particularly reflector design. Many portable flash units can use interchangeable or adjustable reflectors that cover different angles of view. It follows that a reflector that spreads light over a wide area will throw less light on any one point within that area than will a narrow-angle reflector, which will concentrate the same output over a smaller area. Therefore, when you read about the comparative BCPS outputs of competing speedlights be sure the figures are comparable.

On some flash reflectors, the beam angle can be adjusted for maximum lighting efficiency with camera lenses of different focal lengths—from 35mm to 105mm or longer. Such adjustments change the effective light output; but the unit's automatic exposure sensor can compensate.

Watt-Second Rating (or WS). This isn't an expression of light output; it's an expression of the electrical energy storage capability of an electronic flash unit's capacitor. That is, it tells you how much power the unit can store. It is affected by even more variables than a BCPS rating is, because electronic circuitry and flash-tube design directly influence effective light output. WS ratings are only valid as standards of comparison for speedlights of similar design, and this is seldom the case when the units you want to compare come from different manufacturers.

Guide Number (or GN). Somewhere you might read, "Guide numbers are mathematical coefficients for determining the *f*-stop for correct exposure on the basis of an equation of speedlight power and film speed compared to speedlight-to-subject distance under given circumstances." In everyday language, this means that, in order to arrive at the *f*-stop for correct exposure when using a particular combination of film and light power, you divide the source's light GN by the distance from the light to the subject. For example, if your light is 10 feet from your subject and the light's GN is 80 (according to its manufacturer), your correct *f*-stop would be *f*/8.

GNs are based on the fact that as the distance between the light and the subject *increases*, the amount of light reaching the subject *decreases*, and that this decrease is figured on *the square of the distance*. In other words, moving a subject from 5 feet (1.5 meters) away from a given light source to 10 feet (3 meters) away would reduce the amount of light it receives to one quarter (*not* one half) the original amount. This is the Inverse Square Law. Don't worry about the refinements of this law; just remember that the farther away the light is, the less brightly it will illuminate the subject.

Unfortunately, speedlight-to-subject distance is not the only factor determining "correct" *f*-stop. A GN that gives a correct exposure for people in light-colored clothes in a small, white-walled room would lead to disastrous underexposure if used for subjects wearing dark-colored clothes outdoors. Those white walls and light-colored clothes reflect a lot of light. Outdoors, this light is lost because there is nothing to reflect it back to the subject. Thus,

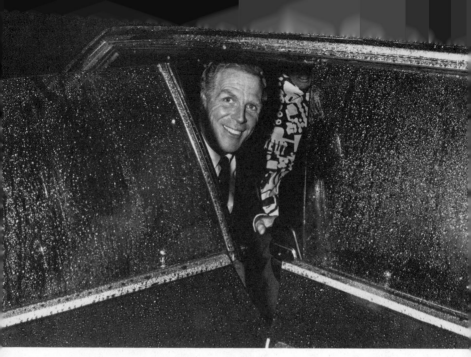

If shiny surfaces are at an angle to the flash unit they will not re-flect light straight back into the lens. In this on-camera flash pic-ture of Kevin White, Mayor of Boston, both wet car windows were at 45-degree angles to the flash. If they had faced the camera at 90 degrees, reflection of the flash would have made the picture impossible.

surroundings and color of the subject are just as important in determining exposure as is distance from the light source.

In the old days, manufacturers were fond of brag-ging about their Kodachrome guide numbers (Koda-chrome being a commonly used film of known speed). However, *ideal* GNs and *effective* GNs are two different things. It pays to be skeptical of manufacturers' assertions. Their GNs usually will be arrived at under circumstances quite different from those under which you'll be shooting.

The only really effective way to compare the rela-tive power of different electronic flash units is either to take test pictures with them or to use an exposure meter designed to read flash output. We'll be talking about these special meters later on.

EXPOSURE CONTROL

Electronic-flash exposure is controlled by ƒ-stop adjust-
ment rather than by shutter speed. This is because the
flash of a speedlight is so much faster than the operation of
a shutter that all you can ask of the shutter is to be wide
open when the flash goes off. And the focal-plane shutters
of most 35mm SLR cameras are fully open only at rela-
tively low speeds.

*Electronic flash expo-
sure is governed by the
f-stop used rather than
by the shutter speed.
The "X" on this shutter-
speed dial marks the
fastest shutter speed at
which the entire film
frame will be exposed
to the quick flash. It is
almost always relatively
slow, often 1/60 sec. or
less.*

Automatic Exposure Makes It Easy

Knowledge of BCPS, WS, and GN refinements is becoming
less and less necessary for speedlight users in the wake of
the growing popularity and availability of automatic-ex-
posure (AE) and auto-thyristor (AT) units. These do the ex-
posure calculations in their own electronic "brains." The
constant-output portable speedlight is still widely used,
but it is now more common at the extremes of the market:
small, inexpensive units for occasional use or heavy, pow-
erful ones marketed for professionals willing to trade off
the convenience of automation for high output and fast re-
cycling.

Both AE and AT devices have an electronic sensor keyed to the speed of the film in the camera and to a particular f-stop. When the flash goes off, this sensor "reads" the amount of light being reflected from the subject and quenches the flash at just the right moment to give correct exposure at that f-stop. The entire process takes place within a fraction of a second. The output of these automatic units is constant; the *duration* of the flash is what controls exposure (which can be as short as 1/30,000 sec.). All the photographer has to worry about is making sure the range of flash-to-subject distances—farthest to nearest—corresponds to the range of intensities—strongest to weakest—of the automatic unit. For instance, if the unit is so far from the subject that even full power won't shed enough light, underexposure it inevitable. In the same way, if the unit is so close to the subject that even the briefest flash will be too much, overexposure will result.

Auto-thyristor flash units do all this and more. Not only do they meter exposures automatically, they also retain unused capacitor energy in less-than-full-power flashing, thereby speeding up recycling time and extending battery life. Some AT units offer a special-use option: a low-power setting with almost-instant recycle, which uses only a small portion of the capacitor's stored power. While this sacrifices automatic exposure control, it does allow the unit to be used for motor-drive and power-winder sequence flash photography at the rate of several frames per second.

Here are two of the many available small flash units: a manually controlled Braun 260B and an autothyristor Vivitar 3500. The circular device near the base of the Vivitar unit is an exposure sensor.

"Dedicated" Units Are Exclusive

The popularity of AT flash photography has encouraged many 35mm SLR camera manufacturers to produce their own units, "dedicated" for use with particular models. These speedlights mate automatically with specialized contacts in the camera's accessory shoe.

The advantages of dedicated flash include electronic keying in of the film speed, which is already entered in the camera's meter system, to the speedlight's automatic-exposure sensor, and a built-in command that sets the correct synchronization speed on the electronic shutter. In addition, many dedicated on-camera flash units incoporate a ready light, visible in the viewfinder, to let the photographer know when an exposure can be made. All the photographer has to do is mount the dedicated unit on the camera and start shooting.

Four 35mm SLR camera "system" lines have taken dedicated AT flash one step further. The Contax 137/139 Quartz, Nikon F3, Olympus OM-2N, and Pentax LX camera bodies accept dedicated AT speedlights that use the cameras' built-in through-the-lens (TTL) metering systems to control flash exposure. While this may seem an unnecessary refinement for everyday flash photography, it

This flash unit, shown here mounted on the Pentax 35mm SLR to which it is matched, or "dedicated," allows a choice of f-stop for automatic operation and has a tilting reflector for bouncing light off a ceiling. While convenient, these dedicated units are designed exclusively for on-camera use—the most limited method of flash lighting.

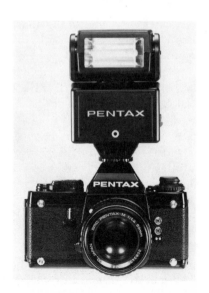

comes into its own when close-up pictures are being made through bellows or extension tubes, which affect the amount of light that actually reaches the film. With a through-the-lens auto-thyristor speedlight, correct exposures can be obtained without the many calculations usually needed for exposure compensation with these close-up devices.

Through-the-lens auto-thyristor dedicated flash units keyed into dedicated flash systems, with their variable-angle reflectors and multiple-source capability, may be convenient and flexible. Still, they can only be used with the cameras they were designed for and then only with the components supplied by the manufacturer. While some independent manufacturers (notably Vivitar, Sunpak, Soligor, and Acme) are beginning to offer speedlights with interchangeable hot-shoe connections that will fit into the dedicated flash systems of cameras from different manufacturers, TTL/AT flash is as yet only a manufacturer-supplied capability.

THE NOMENCLATURE OF PORTABLE FLASH

While the appearance of portable speedlights varies from unit to unit, certain basic characteristics are evident. Starting with manual-exposure (non-AT, non-AE) equipment, you can expect to find the controls and features listed below.

Reflector. This keeps all the light from the flash tube moving in the same direction, generally toward the subject. Many speedlights offer either variable-angle or interchangeable reflectors. These allow you to tailor coverage to the lens you're using or to the area of the subject you wish to illuminate. The instruction books packaged with all flash units list the reflectors' angles. Be sure they match those of the lenses you plan to use.

On/off switch. This controls the battery current. With most units, when you switch it on you will hear a faint, high-pitched whine as the oscillator charges the capacitor. If you don't hear anything, check your batteries—they may be dead or discharged. On many inexpensive

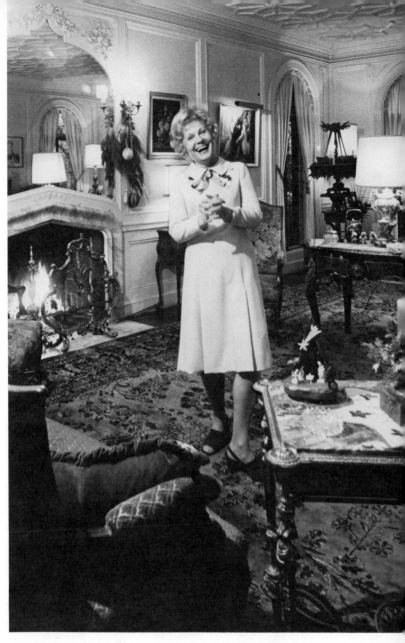

This woman in her living room had plenty of light around her from lamps, windows (reflected in mirrors), and even firelight, but a slight "pop" from an inexpensive low-power flash unit added just the extra light needed to "fill" the shadows, make them gentler and less contrasty. Such synchro–available-light pictures are within the capability of any photographer willing to do some experimenting.

speedlights the oscillator continues to operate as long as the switch is on. More expensive units have a monitor circuit that keeps tabs on the power level in the capacitor. Whenever power drops below full the oscillator turns on automatically to keep up the charge; it shuts off when full capacity has been restored. This is a useful power-saving feature.

Incidentally, be sure to turn the switch off when you're finished using your portable electronic unit. If it's left on, the oscillator will continue to run and will eventually drain the battery completely. If you are using inexpensive replaceable batteries (see Chapter 3, on battery types and maintenance), this will be an inconvenience; if you use rechargeable nickel-cadmium batteries, it's much worse. Nicad batteries can be permanently damaged if they are exhausted completely, and replacements are expensive.

Ready-light. This little orange neon light, usually mounted on the back of the portable unit, winks on (or begins flickering) when the capacitor is fully charged. That is, it's supposed to. Actually, ready-lights are not absolutely reliable. On many units, they actually wink on when the capacitor is about three-quarters charged. Therefore, if you fire the unit as soon as the ready-light goes on, it will deliver less than full power and your picture will be underexposed. The sensors of AE and AT speedlights may compensate for this diminished power, but the circuits that adjust the exposure may be affected by the incomplete capacitor charge and here, again, underexposure will result. To be sure of full power, wait for the ready light to come on, then wait about 25 percent longer than that before you shoot.

Synchronization connection. Most small flash units connect directly to the parent camera via a so-called "hot" accessory shoe. This is a small mounting device incorporating an electrical connection that ties the trigger circuit of the unit into the synchronization circuit of the camera; no external cord is needed. In the case of dedicated flash units, as already mentioned, this connection performs other tasks, too, to make flash operation easier and more

convenient. Hot shoes are standard equipment on most modern 35mm SLR cameras. Before hot-shoe connections were as common as they are now, the only way to plug the synchronization circuit of the camera into the trigger circuit of the flash unit was to use an external connecting cord.

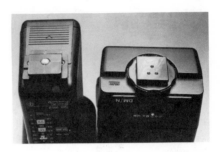

While hot shoes like the single-contact shoe of the Braun 260B (left) do away with sync cords, they restrict the unit to on-camera use. The Vivitar 3500 (right) accepts a special three-contact module that stays on the camera while the unit is used off-camera.

Now, while hot shoes are more convenient, they do mean the photographer must keep the flash unit on the camera. As we'll be seeing, though, this method is a very small part of flash photography. For this reason sync cords are a necessary flash accessory even for the photographer who uses a dedicated unit. Unfortunately, they are also the first part of the flash unit's electrical system to break down.

The most vulnerable link in this already weak chain is the tiny PC plug that actually makes contact with the camera. Held in place entirely by friction, the push-on PC plug is a cause of endless irritation. It always seems to come loose at the wrong moment. It and the cord it is attached to are also subject to internal stresses that can break the tiny wires that carry the current, rendering the cord useless. And it always seems to happen at the most inconvenient time. This problem is so persistent that several makers of 35mm SLRs (including Nikon and Canon) have begun to make PC sockets with a screw thread and to offer special screw-in PC plugs to make sure the sync cord will stay in place. Even if your camera has such a device, though, it's common sense to carry a spare cord, and also to buy PC cords only from manufacturers who offer a replacement policy on "dead" ones (Rollei of America and Para-Mount are two who do.)

Open-flash button. This is a switch that closes the trigger circuit and fires the unit independently of sync connection. Most flash units are provided with an open-flash button, which allows you to check whether your unit is operating without wasting a film frame on an exposure. (It also makes possible some of the special lighting techniques we'll be looking at later in Chapters 6, 7, and 8.) In automatic units, the open-flash button also functions with the ready-light to verify exposure capability (see the *test light* section below).

Exposure calculator. This is found on virtually all nonautomatic (or "manual") on-camera units. It is designed to help the photographer choose the most appropriate *f*-stop without having to bother with guide numbers. All exposure calculators have either a grid coordinate chart or a circular dial and a setting for the film's sensitivity (or "speed") in ISO, ASA, and/or DIN ratings. All you have to do is figure the subject-to-flash distance and then read off the *f*-stop that appears opposite it on the calculator. Unfortunately, these calculators are subject to the same shortcomings as guide numbers are: Not only are the figures provided by most manufacturers suspect in them-

Some manual flash units' exposure calculators are easier to read than others. Never trust the information one of these calculators supplies until you have verified it by testing under the conditions you are likely to encounter.

selves, but also the readings you get are influenced by the surroundings. Be sure you do some test shooting before you take the advice of an exposure calculator seriously.

Bracket. Most users of portable electronic flash expect to mount their unit on the camera at least some of the time. While smaller units may attach directly to the camera with a shoe connection, larger units need some kind of sturdy device to unite the speedlight and the camera into a single convenient piece of equipment.

Let's look at some of the basic requirements for a good flash bracket.

• Quick release. This allows camera and speedlight to be separated instantly for off-camera positioning of the light. The connection should be secure enough to let you carry the camera by holding onto the flash unit.

• Secure grip. Many brackets are molded for easy gripping, but it's worth comparing different brands to find the one most comfortable for your hand. If you're carrying your camera by holding onto the bracket, make sure you can get a firm grip.

• Balance. The auxiliary flash bracket should not destroy the balance of the camera, especially with single-lens reflex cameras. This is where almost all brackets fail. It would seem logical to design a bracket (and a portable flash unit) to place the bulk of the unit's weight below the camera body, yet most brackets make the combination topheavy. As a result, when a 35mm SLR is carried by the neck strap, the flash unit will make it flop forward or to one side. The explanation for this illogical state of affairs is that brackets are usually afterthoughts—the manufacturers' energy seems to go into designing the unit itself, rather than into deciding how to attach it to a real camera.

• Convenience in reloading. Here, again, most brackets fail. Brackets have a rubber-cushioned rail held tight against the bottom of the camera by a setscrew that fastens into the tripod socket. Since many 35mm SLRs have their rewind buttons on the bottom plate, the bracket must be removed before the film can be rewound and the camera reloaded. Since reloading is usually a two-handed operation, some resting place has to be found for the speedlight–bracket combination or it will probably be dropped or stepped on.

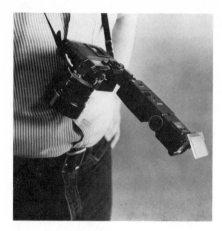

A common problem of shoe-mounted electronic flash units is that they make a camera top-heavy and therefore clumsy to carry. Mounting the unit beside the camera on a bracket sometimes improves the balance, but not always. When buying a flash unit, test it for comfort by operating it under your own everyday shooting circumstances.

While a few cameras (notably the roll-film Mamiya twin-lens reflexes) allow for reloading with the flash bracket attached, they are so rare that over the years professionals have evolved their own designs. Some have attached to the bodies of their cameras custom-made brackets that allow a flash unit to be mounted directly onto the camera in a position where it will not obstruct reloading. If you're interested in such custom designs, write to the Professional Camera Repair Service, Inc., 37 West 47th Street, New York, NY 10036 (telephone [212] 246-7660).

• Angled "shadowless" orientation. Another problem common to side-mounted flash brackets is that they contribute to the strong shadows thrown by subjects standing near a wall. Professional photographers have long used customized brackets that support the flash head *centered* and directly *above* the lens, so that the shadow will fall directly behind the subject and lower down, where it isn't visible. Such devices are available ready-made (from among others, Jones Photo Equipment, Para-Mount Cords and Brackets, and Siegelite Flash Bracket Company).

Besides keeping shadows out of the picture, most of these brackets incorporate adjustments to allow either vertical or horizontal shooting without changing the position of the flash. But they are all clumsy to use. An easier

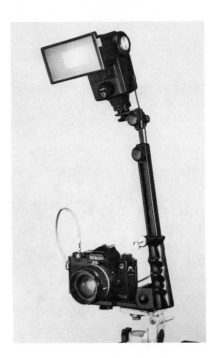

A special bracket like this Siegelite raises the flash unit above the camera and lets shadows fall behind the subjects, out of the picture area; but it might be just as easy to uncouple the unit and hold it in your hand.

solution for shadow-free shooting is to hold the flash unit directly above the camera with one hand while you operate the camera with the other.

Charging plug. Most portable speedlights using rechargeable batteries supply a plug to allow charging from an outside power source—usually house current, via a step-down transformer. The exceptions are a few professional units that have separate chargers, allowing the unit to be used while another set of batteries is being recharged. Separate chargers are also available for some small units. Most portable devices can be operated on house current, too, so that you can save your batteries for the times when a wall plug is not handy.

When you plug in the outside power cord be sure the on/off switch is set properly. Correct setting varies from brand to brand. Incorrect setting can destroy some units, turning them into globs of melted plastic. Needless to say, such abuses also constitute a fire risk.

Battery compartment. Most small portable units have a small compartment, with a snap-off or sliding plastic lid, to hold the batteries. Inside this compartment is a diagram showing the correct way to insert the batteries. Follow this diagram carefully. Current flowing in the wrong direction through your flash unit will cause nothing but trouble.

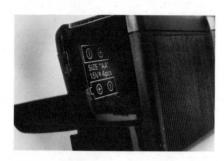

Inside the battery compartment of this Braun flash unit is a chart showing the correct way to insert the batteries. Be sure to follow these instructions carefully. Incorrectly inserted batteries can seriously damage the unit's circuitry.

Some larger, more powerful appliances have separate power packs that contain not only the batteries but also the capacitor. A power cord connects the pack to the flash unit's lamp head. As a consequence, the heads are lighter and easier to handle than the one-piece units; but you still have to carry the pack—over the shoulder or around your waist.

In either case, batteries should *never* be left in your flash unit when it's being stored (provided they're the removable kind; some rechargeables aren't). So-called "dry cell" batteries are only dry on the outside. Inside they're moist, and if they're left in the unit without being used they will begin after a time to secrete a corrosive liquid that can damage the interior of the unit—not to mention the fact that corroded batteries are almost impossible to remove.

NOTE: Before inserting batteries into your portable flash unit, look to see that the on/off switch is at *off!* This is easy to forget, but as a result the batteries could be drained completely before the unit has fired a single flash.

For Automatics Only

All the features described above are common to most portable electronic units, whether humble manual units or so-

44

phisticated auto-exposure (AE) or auto-thyristor (AT) ones. AE and AT units, however, share additional features not found in their manual cousins.

Sensor. This tiny electronic component is what "reads" the effect of the flash on the subject. It quenches the light when the correct exposure has been reached—all in a fraction of a second. Simpler automatic speedlights have the sensor beside or below the *reflector* and pointing in the same direction. More complex units use a remote sensor (or offer it as an option). A remote sensor is mounted on the *camera* rather than on the flash unit and always points in the same direction as the *lens*, regardless of the position of the reflector. It allows a wider choice of lighting techniques but still retains control of the exposure.

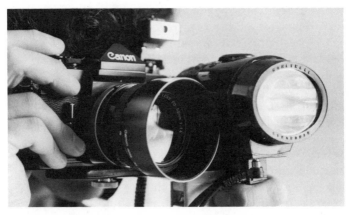

A flash unit held very close to your lens may give you almost shadowless pictures, but in color shots you may see "red eye" if your subjects are looking directly into the lens. Tell your subjects not to look at the camera, or have them look briefly into a bright light to "stop down" their eyes and lessen the chances of "red eye." Holding the flash off the camera will also eliminate the problem.

Film speed selector. All AE and AT units must be keyed to the sensitivity ("speed") of the film in use in order to obtain the most accurate results. This information must be entered somewhere in the unit's electronic circuitry. The setting of the ISO/ASA/DIN film-speed rating will decide the unit's calculations of exposure.

Distance-range indicator. The highest and lowest power output the speedlight can produce will dictate the range of distances at which you can rely upon it for accurate automatic exposures at a given ƒ-stop. For example, a certain automatic electronic flash unit might illuminate subjects at a distance of 20 feet at the unit's full power but only 6 feet (2 meters) away at its lowest power. Automatic units have an indicator that defines these limits; the limits must be adhered to if you want accurate exposures.

While simpler automatic speedlights give only one ƒ-stop for a given film speed, more advanced models offer either a series of power levels or a continuously adjustable power control that permits a choice of lens openings. This allows the photographer to control depth of field while the speedlight retains automatic exposure control. This is especially useful when there is a need for both shallow zone of sharp focus (large ƒ-stop) and great depth (small ƒ-stop) in the course of a single picture-taking session.

Test light. Several manufacturers have added a test light to make the verification of flash-to-subject distance simpler. If you want to check that your unit can handle the distance you're shooting at, use the open-flash button to set off a test flash. If the test light winks on (or, in some units, the ready light blinks instead), you know you can get correct exposure at that distance.

Test lights have a limitation, however. They can be trusted to indicate potential *under*exposure but they won't tell you anything about potential *over*exposure. You may be working so close to your subject that the automatic unit's lowest-power flash will still overexpose the picture, and the test light will not warn you. Therefore, if you are doing close work with automatic-exposure flash, you should be especially careful of your unit's limitations.

Power-level control. This feature is found on some models of both manual and automatic speedlights. Its function on manual units is straightforward: to cut the power for close-up lighting or to provide more control if several units are being used to illuminate different areas of the same picture. Most offer a choice of full and half power, but a few units offer quarter power, too. The lower

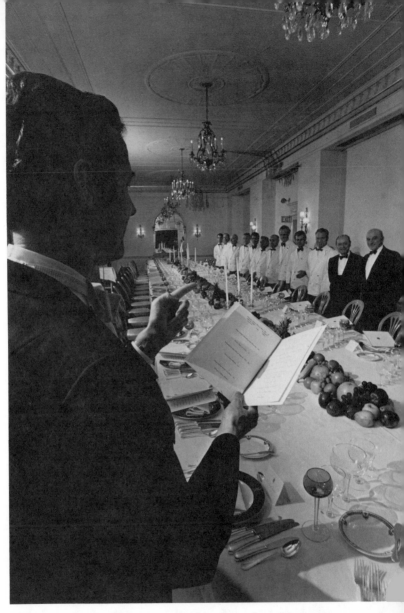

This scene of waiters being instructed by the maître-d' before a gourmet dinner at a Boston hotel was posed before the guests arrived. Two bare-tube flash units were used to cover the vast area "seen" by the 20mm lens: one unit close to the foreground figure to illuminate the menu and the table setting near the camera (notice the shadows), the other halfway down the wall on the left (notice the highlight on the ceiling). Using 90-watt-second Honeywell 65D flash units and Tri-X film, it was possible to use a flash exposure at f/8.

47

power settings decrease recycling time because the full capability of the capacitor is not being used.

Power-level controls on automatic speedlights may give the user a choice of different f-stops with film of a given sensitivity. Some auto-thyristor (AT) speedlights provide almost-instant low-power recycling for sequence shooting with power winders. This brief recycling time is activated by a special switch that takes the unit off automatic operation and sets it for a low power level. Since AT speedlights use only a fraction of the capacitor's capability for low-power flashes, the result is a fast recycle; but there is a trade-off—the flash will be weak and you will forfeit the automatic adjustments of exposure.

Some AE units—like the TLA20 speedlight, which is dedicated to the Contax Quartz cameras, models 137 and 139—have a single low-power setting to use when fast recycling is needed. The nondedicated Sunpak 411, which can be used with almost any camera, offers "power-ratio control." This simply means that the power can be cut by any amount down to 1/32 of the unit's full strength. The contrasty light from small reflectors also tends to drop off very quickly as light-to-subject distance increases. This is why backgrounds in many flash pictures appear very dark unless the subjects have been posed a little way in front of a wall.

Contrasty light makes the precise determination of exposure more important because of the film's lessened exposure latitude. Unfortunately, the fact that the smallest speedlight units are often nonautomatic makes correct selection of f-stop a finicky calculation based upon always-variable guide numbers.

Small Reflectors = Narrow Angles

In addition, many small reflectors throw a beam of light too narrow for lenses of a wider angle of view than that of the 45–55mm lens considered normal on a 35mm SLR. They illuminate only the center of the field of view of lenses with 35mm or 28mm focal lengths.

Many of the new speedlight units have been provided with accessories that let them handle the wider angles. Among these are Spiratone's Spiralight Supreme,

which has a "spreader" accessory said to cover a 100-degree angle of view, Rollei of America's Strobo Domes, designed for their Honeywell speedlights; and such interchangeable reflectors as the Norman 200B. The Vivitar 265, 285, 365, and 385 speedlights incorporate variable-angle reflectors that match the light's angle of coverage to the lens's angle of view for lenses from 28mm to 105mm in focal length. Naturally, recycling time decreases as the power level is lowered.

A number of flash units offer control of the area illuminated by each flash. The beam angle of the Vivitar 3500 unit's reflector is controlled by sliding the front section forward for a narrow angle (left) and back for a wide angle (right). Be sure to check the beam at its widest setting with your widest lens to see if light coverage is even: At wide-angle beam settings with wide-angle lenses, many flash units will leave you with dark corners to your pictures.

Besides shortened recycle times, low power settings offer the benefits of decreased flash duration—in the case of the Sunpak 411, the flash can be as short as 1/15,000 sec. If your interests run to high-speed photography, use of power-level control is an inexpensive way of getting a short-duration flash. Just remember that it will be weak.

REFLECTORS, COVERAGE, AND CONTRAST

The reflector of a portable flash unit controls more than the direction of the light from the flash tube. It controls angle and contrast, as well.

Most portable lighting units are just that—portable. Today, some units are so tiny that one can fit in the palm of your hand with room to spare. In the process of miniaturization, however, reflectors have shrunk along with the units' other components—and small reflectors throw contrasty light.

Contrasty light is hard, sharp light similar to direct cloudless, midday sunlight. It is unflattering to many subjects, as it throws dark shadows, reveals fine detail, and has a narrowing effect on exposure latitude (a film's ability to produce an acceptable result at other than the correct exposure). Soft, low-contrast light is similar to overcast daylight. It gives a light that is more even, and therefore more flattering; light that puts fewer limitations on a film's exposure latitude.

The smaller a light source's reflector, the higher the contrast of the light.

Besides covering the fields of view of wide-angle lenses, wide-angle speedlights also provide a less contrasty, more flattering light that can enhance the quality of your pictures.

Wide Angle = Thinner Light

It is always necessary to bear in mind that as the angle of a speedlight's reflector increases, the unit's ability to light any single point decreases. It's analogous to spreading pats of butter of the same size onto larger and larger slices of bread: the larger the slice, the thinner the butter will be. A speedlight that will illuminate a subject adequately 20 feet (6 meters) away with a *narrow* beam of light may not be able to do the same job beyond 10 feet (3 meters) with a *wider* angle of coverage. This makes automatic flash units so convenient to use: Just set the film speed, stay within the stipulated range of distances, and the unit's electronic brain does all the exposure calculations for you.

50

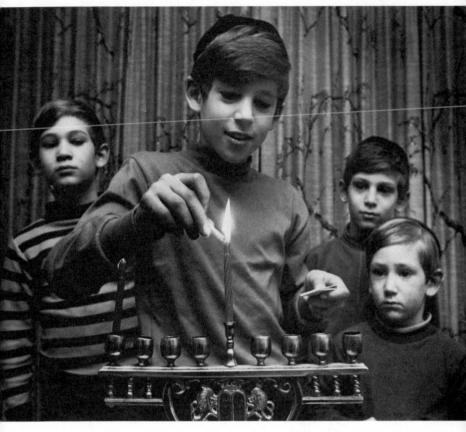

The shadows under the youth's eyebrows indicate that light from the flash source was bounced off the ceiling. The low-contrast, all-over light that resulted models the faces without overpowering the candle flame. Selective focus was used for this scene to emphasize the menorah candelabrum.

Reflectors correct for extreme-wide-angle coverage are rare. While a number of manufacturers say they offer superwide reflector coverage, their units must be positioned carefully on the camera in order to match the lens's angle of view. This robs the photographer of the benefits of off-camera flash. Even worse, when wide-angle lenses are used up close, as they often are, the drop-off of light from the camera-mounted appliance is particularly noticeable and inconvenient. The foreground winds up catching most of the light, leaving the background jet black.

Alternatives

One solution to the wide-angle-coverage problem is found in the auxiliary reflectors developed by manufacturers for units equipped with swivel-direction reflectors (such as the Vivitars). The head is pointed straight up at a white-card reflector positioned above it at a 45-degree angle. The result is soft, wide-angle bounce lighting. It works; but it does make for a big, top-heavy unit.

The bare tube offers another solution, since it has no reflector at all and so throws light in all directions. There's a price to pay; Much light is wasted. In fact, if you don't have white, reflecting walls most of the bare tube's output will be lost completely. Nevertheless, for close-up photography indoors with wide-angle lenses, the few bare-tube units made offer capabilities unmatched by reflector units. As we'll be seeing later (in Chapter 6), the bare tube, with its "blob" of light, can be useful with lenses of any and all focal lengths.

3

About Batteries

A portable electronic flash unit is only portable if it's independent of outside power sources. This means it must be battery operated. While there are malfunctions every day in the flash tubes and electronic circuitry of portable electronic flash units, the Number One cause of missed flash pictures is battery failure. The more you know about battery selection, application, and maintenance, therefore, the fewer disappointments you'll have.

Portable flash batteries fall into two categories: nonrechargeable (also called "primary") cells and rechargeable (made with nickel-cadmium). In deciding which type to choose, you'll want to give some thought to photographic circumstances—the conditions under which you'll be working and the kind of pictures you'll want to make.

PRIMARY BATTERIES

There are two kinds of primary batteries. *Carbon-zinc* batteries are available in voltages of from 1.5 to 510. The more expensive *alkaline-manganese* cells come in voltages of from 1.5 to 9. Both are made in a variety of sizes; from small "penlight" AA size to medium-sized C and flashlight-sized D. There are also sealed four-cell AA "flat packs", which snap into certain speedlights as a single convenient unit. How do you know which to choose?

Alkaline-manganese batteries are more expensive than the carbon-zinc types, but their electrical characteristics make them worth the extra expense. They'll give you more flashes and shorter, more consistent recycle times.

Carbon-Zinc Versus Alkaline-Manganese

Carbon-zinc batteries consist of a zinc outer shell and a carbon center rod. A damp mixture of manganese dioxide, ammonium chloride, zinc chloride, chrome inhibitor, carbon, and water fills the space in between; so these "dry cells" are actually dry only on the outside. It's the chemical reaction produced by this mixture that produces the electric current.

When you go looking for carbon-zinc batteries, you'll find they come in different types for different uses. The "photoflash" carbon-zincs are the ones to buy. Their internal chemistry is especially formulated to accommodate a speedlight capacitor's need for a fast rush of energy as it recycles, followed by an idle interlude when the capacitor discharges (producing a flash), followed in turn by another call for a big rush of energy. The other types of carbon-zincs are designed for the low, steady drain expected from a flashlight; they are to be avoided for flash applications.

Alkaline-manganese batteries have potassium hydroxide in place of the chloride salts used in the carbon-zinc cells. This powerful, highly conductive alkali mixture gives the cell a larger power-reserve capability. Alkalines are less affected by the demands for high power that speedlight operation places on batteries, and so recycle times remain more consistent throughout the life of the battery.

Alkalines tend to be the wiser purchase for all but the most casual flash photographers. They may be more expensive than carbon-zinc batteries, but their increased capacity works out to a lower cost per flash. Under the

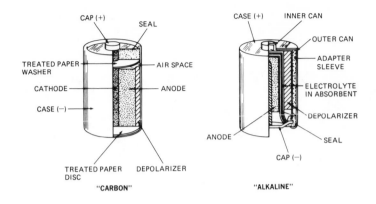

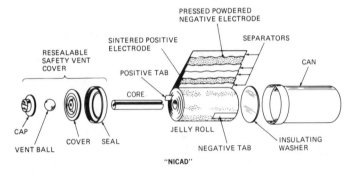

Batteries may look alike on the outside, but here you can see differences in structure of three main types: carbon-zinc (top left), alkaline-manganese (top right), and nickel-cadmium (expanded view, bottom). (Drawing by Vantage Art)

right conditions (for example, if you must shoot a lot of flash pictures in a hurry), alkalines can actually provide two or three times as many flashes as carbon-zincs are able to, and they have a better shelf life (after one year at 70 F, they can still be expected to operate at 90 percent of their capacity). They also function over a wider temperature range: 32–100 F (0–37.8 C) for most use; and they can tolerate a range of -20 F to +140 F (-28.9 C to +60 C) with only partial loss of performance.

If you're looking for ultrafast recycle times, though, the *carbon-zinc 510-volt* battery is virtually in a class by

In fast-moving news situations like this one, on-camera flash is the only way to get any pictures at all. Running along beside this politician as he was being pursued by well-wishers, I held the camera over my head with both hands and shot blindly.

itself; only a couple of expensive rechargeable units can match it. Many manufacturers of small one-piece speed-lights with low-voltage batteries also supply special fast-recycle power packs that use this high-voltage, expensive, nonrechargeable brick-sized cell. A fresh 510 not only re-cycles as fast as one second but also provides the high power unobtainable with AT units at rapid-recycle low-power settings.

Check Batteries Before Buying

Primary batteries cannot be recharged. They are fresh only when they are new, and thus it makes sense to do your battery shopping at a store with a brisk turnover. Also, check your old batteries before you buy new ones. Most stores have simple battery testers customers can use. Don't lay out money for new batteries until you know the condition of those you already have.

Here's a tip for buyers of Mallory Duracell batteries: There's a date code stamped on the package. The first digit is the last number of the year of manufacture. Then comes a letter designating the month—the code runs from "A" (January) through "L" (December). Third is the number of the day of the month of manufacture. The final letter desig-nates the factory. Knowing this code, you can be sure of getting fresh batteries (provided they have been stored in the cool, dry surroundings that do the best job of preserv-ing a battery's electrical vitality).

RECHARGEABLE BATTERIES

The third type of battery is the nickel-cadmium (or "ni-cad", for short). Unlike both carbon-zinc and alkaline-manganese batteries, nicads can be recharged. Most units designed to use nicads have a charger built in. You can also buy a recharger that will work off house current. You can use it to charge a spare set of nicads while you are us-ing your unit, or, as we shall see, to charge nicads for use in place of primary batteries in units that have no built-in charger.

Most nicads are low-voltage batteries with recycle times of from 5 to 20 seconds, but a few special fast-recycle speedlight units are available. The Permacad power pack, manufactured by Rollei of America for certain models of their Honeywell flash units, gives about 100 flashes per charge with a two-second recycle time and three-hour recharging. The Lumedyne N200 and N204 and Norman 200B units provide super-fast recycling with their nicad power packs. These units, however, are both nonautomatic and expensive.

The nickel-cadmium inserts (left) for the Honeywell Permacad Power Pack can be recharged in three hours by an external charger (right). Each insert provides 100 full-power flashes. Note the voltage-adjustment switch on the charger; this allows for use in foreign countries.

While nicads start out more expensive than primaries, the fact that they can be recharged as many as a thousand times makes them very attractive. They are especially economical for photographers who do a lot of work with flash. But even photographers who use their units only occasionally will find nicads offer another advantage: Primary cells can wear out from nonuse, but nicads can be charged up whenever they are needed. Price per flash is the lowest of all battery types. For heavy users, recycle time is not only consistent but also shorter than it is for primary batteries. And nicads are available in the same range of sizes as primaries.

Small nickel-cadmium battery chargers like this are available from many manufacturers. Nickel-cadmium cells fit into the same battery compartments as primary batteries and are cheaper, flash for flash. But make sure that using them won't damage your flash unit (see text). If in doubt, write to the manufacturer of the unit.

Nicads Versus Primaries?

From the foregoing, it would seem that nicads make an attractive substitute for the nonrechargeable primaries if you use your equipment a lot. But is this really the case?

It depends. While some nicads are the same size and shape as primary electronic-flash-unit batteries and will fit into the same battery compartments, their characteris-

Here is another type of battery charger. This one, for AA-size batteries, plugs right into a wall socket. If you use flash illumination often, and if your flash unit can use rechargeables, the investment for batteries and charger together can pay off.

tics are different enough to cause problems with some units.

First of all, nicad batteries give slightly lower voltage than their primary cousins do. As a result, an electronic unit's capacitor-charging circuits have to work longer and harder with rechargeable batteries than they do with primary batteries. Also, the longer electric current flows through these circuits, the more heat is generated. Some units may not have been designed to handle this heat. The result can be increased wear and possibly even damage to the unit.

Second, nicads have a more even voltage output. If you are shooting a lot of flash pictures quickly, primary batteries will become depleted temporarily; recycle times will increase in order to give the unit's circuitry a chance to cool off. Nicad batteries, on the other hand, keep putting out the same voltage as long as the charge holds, which can cause damage to a unit designed for longer recycle times.

Third, the battery compartments of many small speedlight units built for primary batteries are of a size to accept nicads, but it does not necessarily follow that nicads can power that unit. Check your unit's instruction book carefully: If it states specifically that nicads are not recommended as a power source, *do not use them.* If there's no statement one way or the other, you're probably safe; but it's worth a call to the manufacturer or importer to make sure.

Nickel-cadmium batteries give fewer flashes per charge than *fresh* alkaline-manganese primary batteries can provide. They also take a long time to charge up—usually overnight for a full charge, although a few rapid chargers are available. In addition, because nicads have a consistent power yield they don't give you the warning primary batteries do when power is running low. With primaries, recycle times increase as the power gradually decreases; nicads just stop giving power all of a sudden. (It always seems to happen when you least expect it!) If you don't use flash often and your unit can use either type interchangeably, it might be a good idea to keep a spare set of alkalines handy for extra shooting in case your nicads die. If you do a lot of work with flash, of course an extra set of the nicads would be worth the expense.

Memory and Other Nicad Oddities

Nicads have two other characteristics that need to be understood if you're to get the maximum benefit from them. One of the most important is the so-called "memory effect." Basically, nicad batteries perform in the way they've been "trained" to. If you routinely (and consistently) take a dozen flashes on a set of nicads and then charge them, you'll find that the nicads have "learned" to give about a dozen flashes and won't give more even when they are capable of doing so. This effect can be cancelled if, from time to time, you use up most of the batteries' capacity (but not all of it!) and then recharge them fully—thereby eliminating their "memory."

If it is not convenient to use up the nicads' power by firing off your speedlight, put them into a regular household flashlight, turn it on—and leave it on. When the light grows dim, take out the nicads and put them back into their charger to rebuild their strength, free of the limitation.

Another characteristic of nicads is "reverse charging." This happens when the cells are fully discharged; for example, in the situation just described, or if you should leave your unit's on/off switch at the "on" position.

In reverse charging, the weakest battery in the group of two or four becomes exhausted; then, as the cells are wired in series, the other cells continue to feed current through the exhausted cell and ruin it. When this destruction is complete, the whole group of batteries will stop working—making you think they're all dead. This is seldom the case. Recharge the group, and then check each cell separately, using a flashlight or a battery tester. The completely dead battery is the only one you will need to replace.

Caring for Nicads

Taking care of your nicads will keep them operating at their best. Some reminders follow.

• Never just carry your spare nicad batteries in your pocket. They can be short-circuited by loose change or keys and can generate enough heat to burn you. Your ni-

"Dry cell" batteries are actually moist inside and can secrete corrosive liquid when they get old (below). Keep the contacts clean (left), using a rough rag or a pencil eraser on both battery and compartment, and take the batteries out when not in use. Dirt or corrosion can decrease current flow, lengthen recycle times, even damage the unit.

cads should be kept together with a rubber band and also wrapped in a heavy plastic bag for safety.

• Remember to clean the contacts (assuming you're dealing with removable batteries) whenever you take them out of the unit. Tiny amounts of vapor escape from nicad batteries and can form a film on the contacts that will impede the flow of current. All you need to do is wipe them with a rough rag or a pencil eraser, following with a cloth, to remove the bits of eraser. (By the way, the same

cleaning method is advisable for primary batteries.) Clean the speedlight unit's contacts, too.

- Be sure to keep your nicads dry. Sodium hydroxide, the electrolyte in nicads, has an affinity for water. The rubbber seal on the nicad cell not only allows the escape of gasses during normal use but also can permit moisture to enter the cell, drawing out some of the sodium hydroxide and forming a white deposit around the seal. A humid day, a sweaty pocket, or rain can supply enough moisture to cause trouble.

- Since nicads are usually used in pairs, numbering them by twos will help you control and test them more efficiently. For instance, such classifying makes them easier to check out with a flashlight when performance starts to go down or when you suspect reverse charging. Give a nicad that seems weak a really good charge before abandoning it. The weakness may be due to the cell's memory characteristic—it may not be bad at all but just "accustomed" to light use, as was explained earlier.

HOW TO STORE BATTERIES

No matter what kind of batteries you use, *never store the unit with the batteries inside*, particularly if you're using alkaline-manganese cells. These otherwise-desirable power sources suffer from a phenomenon called "salting": A corrosive deposit escapes through the seals at the end of the cell and can corrode the contacts of the battery compartment. Minor salting can be rubbed off with a pencil eraser (as just described for nicads), followed with a cotton swab or rough cloth to remove the bits of rubber. Inspection of your batteries and battery compartment should be routine.

Batteries of all kinds suffer in hot weather. Heat speeds up their internal chemical reactions and hastens the end of their use as power sources. Conversely, cold surroundings, while they slow a battery's output, also increase its life. When you're not taking pictures, keep your speedlight batteries in the freezing compartment of your refrigerator, wrapped in a sealed plastic bag along with a

The late Arthur Fiedler, conductor of the Boston Pops Orchestra, and his son were captured with a single flash on the camera. Because the car's windshield sloped backward, the flash was not reflected directly back into the lens.

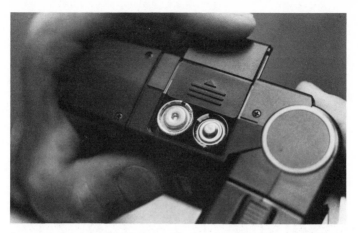

Be sure to load the batteries correctly in your new flash unit. This orientation, or "polarity," is crucial for correct, safe operation. Also be sure the on/off switch is off, or the power drain of the oscillator could exhaust your batteries before you take the first picture. And of course never store your unit with the batteries inside.

moisture-absorbing silica gel cartridge. If your camera or hardware store can't supply you, write to the Hydrosorbent Company (see suppliers' address list in the back of this book). Silica gel cartridges are reusable and can be reactivated by heating in a warm oven according to the manufacturer's directions.

Be sure to take your frozen batteries out of the freezer far enough ahead of your picture-taking schedule to let them warm up to room temperature. (This will take about six hours.) Since moisture will condense on the cold batteries, be sure to keep them sealed in the plastic bag until they have warmed up: *Moisture is as dangerous to battery life as heat is.*

A final tip for battery care: If you're having trouble with your unit and decide to ship it to the manufacturer's service department, include the batteries you've been using. Don't ship them inside the unit, but *wrap them separately* in the same shipping carton.

As was said at the beginning of this chapter, battery problems account for more missed flashes than any other cause; so when you take your unit's problems to a repair shop, be sure that you have included all of them—especially the batteries.

4

Shopping for Equipment

If you go to any well-stocked camera store, you will see dozens of portable electronic flash units for sale. Many look alike, and the salespeople may tell you about them in terms you don't understand. How do you make up your mind?

Start out with the realization that the more flustered you get and the less knowledgeable you are, the more mistakes you'll make. The first three chapters of this book have tried to give you a basic knowledge of how portable flash devices operate and are powered. This chapter is intended to help you evaluate the capabilities of various models in respect of *your* photographic interests and needs.

A GOOD STORE IS A SUPPORTIVE STORE

An important first step is to choose a store that is both nearby and willing to refund your money if a unit turns out not to be what you wanted, after all. Such a variety of equipment is available that it is understandable if you change your mind once you start taking pictures with a new speedlight. An even more desirable store is one that will let you try out several units by actually taking pictures with them to see how you like the "feel" of each one. Some stores will allow you to rent different units, with the rental

To document amateur night in a Boston Irish bar, the author mounted a slave flash on the ceiling to the left of the camera to illuminate the background and a bare-tube flash at camera position to illuminate the quartet.

fee deductible from the price of the unit you finally decide on. Don't be embarrassed to ask questions, and don't be afraid to walk out of a store if the salespeople are less than sympathetic and knowledgeable. The merchandising of photographic equipment is a competitive business these days. If one store isn't helpful, look for another that will be. And cement relations by taking more of your business to the helpful store.

Compare Prices

How do you decide how much you should pay for an electronic-flash unit? Although every portable flash unit has a list price, few stores sell at that price; the units are nearly always heavily discounted. As a first step, go through a buying guide looking for the units that seem to match your needs. One that professionals use is the Photographic Trade News Publishing Corporation's *Master Buying Guide and Directory* (or *PTN Directory*, for short). Other guides include the *Photo Weekly Buyers Handbook*, the *Photo Buying Guide* from *Modern Photography* magazine,

Popular Photography's Photography Directory and Buy-ing Guide, and *Industrial Photography* magazine's *Gold Book.* These annually updated books list not only flash units and accessories but also virtually all photographic equipment on the market. Checking out a buying guide is the best way to get an overview of what's available be-cause it lists a wider variety of equipment than most cam-era stores could be expected to stock at any given time. The cost to you in money and in time is a bargain in ex-change for the sophisitication you'll gain.

Once you've narrowed your range of choices down a bit, look at current issues of *Modern Photography and Popular Photography* magazines. Check through the ads in the back. The shortcoming of all the mail-order supplies is that all they do is sell equipment; they don't offer any support to their far-flung customers. The chief value of their ads to the novice is to let you know what the lowest prices are likely to be.

Do some research on the features of different flash units before you go to the store to look them over. The annually updated PTN Master Buying Guide *is one source of information. Many flash units resemble each other, but they have enough differences un-der the skin to make choosing one a complicated task; you can't go by appearances.*

If you've done your homework well, you'll now know roughly what you can expect to pay for a particular unit. Your local store probably won't match the mail-order prices. They can't. Mail-order dealers buy in huge volume and get discounts to match. Yet your local dealer should be able to come reasonably close. Remember that the difference in cost pays for the support and advice you can expect to receive from the local camera store.

DECIDING WHAT YOU NEED

By the time you actually start visiting stores to try out flash units, you should have some basic idea of what you will need. (Please note that any prices quoted here are only given for purposes of comparison; the basis is the 1981 U.S. dollar.)

Some Basic Questions

1. What kind of pictures do you expect to take? If you're only interested in taking close-up snapshots of your family, all you'll need is a small camera-mounting automatic-exposure (AE) speedlight, which you should be able to find for less than $50. Most of the on-camera flash refinements—high power, thyristor circuitry, variable-angle reflector, remote sensor—would be excess baggage.

2. Are you in a hurry? The auto-thyristor (AT) units give fast recycle times but only for close-up shooting. If you expect to be photographing large groups, you'll need a more powerful unit. The only units with short recycle times that offer automatic exposure at long ranges are the expensive ones with specialized fast-recycle batteries.

3. How interested are you in flash photography? If you really want to explore the potentials of flash you'll need a unit with a wide range of capabilities. Here the buying guides are especially valuable because they list the features of each unit.

4. How much are you willing to pay? As of this writing, pocket-sized nonautomatic, low-power appliances can cost less than $20, whereas powerful AT units

with all the trimmings can cost hundreds of dollars. Generally speaking, you get what you pay for. The question to ask yourself is: Do I need it?

There are two ways of considering the features-versus-price question. The first is to figure that if you're just starting out, all you need is a basic, simple, inexpensive flash unit. If you want more features and options later on you can buy a better and more expensive unit then. The second way is to figure that you can buy a complicated unit now and grow into all its features as you gain experience.

The debate is an old one, having more to do with ambition than with cost. There is a lot of sense in starting out with a simple unit. The "bells and whistles" of the complex units tend to bewilder beginners, and the likelihood exists that, in the time it takes you to grow past your basic flash needs, an even more advanced unit will have come on the market. All electronic technology is fast advancing, and each year's photographic equipment seems to offer attractive new features. All things considered, it's easier to accept the obsolescence of a $50 flash unit than of a $200 one.

Types

Portable speedlight units fall into three basic categories: small, medium, and large. Each has particular capabilities.

Small. These combine all components—reflector, capacitor, circuitry, and power source—in a single package. The smallest are tiny affairs with only enough power for close-up shooting (15–25 watt-seconds) and no provision for AE or AT exposure control or power economy. On the other hand, some of the small units have full AT capability and a number of useful features, including reflectors that can be pointed in different directions. If you're a casual flash photographer, one of the better-equipped small units is all you'll need.

Medium-sized. These generally offer more of what the good small units have: automatic operation, reflector-angle adjustment, and, frequently, monoblock construc-

133A 155A 177A 199A

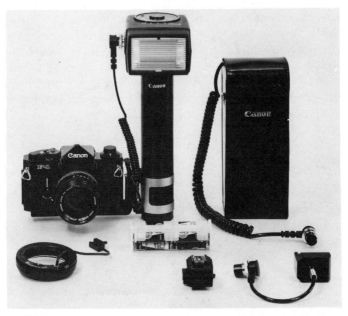

Top picture: *Many camera manufacturers offer a variety of electronic flash units to match all their different camera models. This assortment is from Canon.* Lower picture: *Sophisticated systems sometimes give a choice of power sources. This Canon Speedlite 500A can use internal nicad batteries in a cluster-pack (center) for normal 10–15 second recycle times or a fast-recycle high-voltage pack (right), which uses a 510-volt dry cell.*

tion. One difference is that, where the small automatic units might offer only one or two f-stops for automatic operation at any given film speed, the medium-sized units might provide a larger choice and/or a continuous range

of settings. Medium-sized units are also more powerful (in the range of 40–80 watt-seconds), and this makes for greater ranges of shooting distances and/or the opportunity to use slower films. Such useful features as remote sensors and wide-angle reflectors are more common on medium-sized than on small speedlights.

Large. Here are the most powerful units of all. They are mostly of two-piece design in a head and a power pack, connected by a power cord. They offer power of up to 200 watt-seconds and fast recycling, which make them attractive to professionals. A few of the large units have automatic exposure control, but the majority are manual. While they can include an impressive range of studio-style options, including extra flash heads and interchangeable reflectors, the large units often comprise more equipment than an amateur either needs or is willing to pay for: Prices can climb over $500 for such deluxe fast-recycling units as the Lumedyne N200 and the Norman 200B.

A BUYER'S CHECKLIST

Now that you have some idea of the type of speedlight you'd like to inspect, here are some of the considerations to have in mind as you look it over.

Portability

If it's a one-piece unit, what's its weight? (Be sure to judge this weight with the batteries inserted.)

If it's a two-piece unit, what's the weight of the power pack? the lamp head? Is your camera easy to carry with the unit in place? Remember to take all your cameras along to check this out. If you have your eye on a new camera, try to borrow one long enough to see if it agrees with the new electronic flash attachment you are examining.

Does the mounted unit put a dangerous strain on the camera?

How many mounting options are available? Is a hot shoe the only way to mount the unit to the camera? If so, your options will be limited.

Ask to see what brackets—if any—are available. In reading buying guides you will discover that independent suppliers offer ingenious brackets for many speedlights, even though many flash manufacturers seem to regard brackets as afterthoughts.

Will any of the brackets available mount securely on your camera, or do they become dislodged and put the speedlight in the wrong position?

Could the bracket damage your camera?

Is a quick-release bracket available?

Can you operate your camera's controls easily with the mounted flash device in place?

Can you reload film with the flash unit or bracket in place?

Is the power pack easy to carry? If separate, can it be fitted into your gadget bag or must it be carried by itself? (If the latter, you'll have a clumsy load when you try to take both along with you.)

Multiple flash can produce some unpleasant surprises, like the bright glob of light from the slave flash and the floating bubbles caused by flare in the camera's lens. In addition, one woman has her eyes closed and the face of the other is half in shadow. Polaroid test shots can help foresee and avoid such errors.

Does the separate power pack ride comfortably on your body? Is it a convenient shape? Has it any protrusions that could catch on your clothing? Will the strap stay on your shoulder, or will it slip off? Is the strap adjustable for length? Will it stay flexible in cold weather? Will it discolor your clothes?

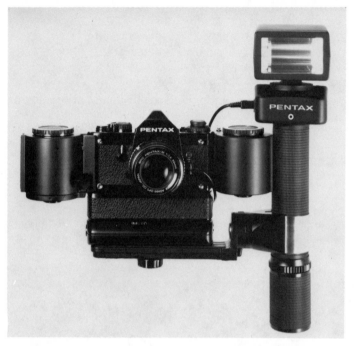

Manufacturers of "system" 35mm SLRs are fond of coming up with pictures like this, showing every possible accessory that can be crammed onto the camera at once. This Pentax LX has motor drive, 250-exposure back, and dedicated flash unit. Buy the accessories you need, not necessarily all that are available.

Are there any other carrying options? Is belt mounting available?

Will the power pack or the one-piece unit stand alone? or will it topple over?

Can you lay the unit down while it's attached to the camera without having it set off the open-flash button?

Are the power pack's plugs easy to reach? how about when the pack is shoulder mounted?

How about the switches and controls on the unit

and on pack? Are they comfortably placed? of convenient size? Can you operate them when you're wearing gloves?

Is the pack-to-head power cord long enough? Are extensions available? Is it a straight or a coiled cord? (Coiled cords are less prone to tangling but are often inconvenient for off-camera shooting, as they can get in front of your lens.)

Are the power pack's fittings rustproof? Is the casing strong? Will it survive being dropped?

Can the head and the power pack be attached for convenient carrying?

Ease of Operation

Are all the controls easily accessible?

Can you read the control buttons and indicators even in poor light? Alternatively, is there a built-in illuminator for use in poor light?

Can the controls be operated with gloved hands?

Can the controls be safely operated in the rain?

Can the controls be identified by shape as well as by appearance?

If the unit has replaceable batteries, can they be changed conveniently and quickly? Can they be changed when the unit is mounted on a camera?

Does the battery compartment have a loose lid that might easily be lost?

Can batteries be inserted incorrectly without your realizing it? Are battery-insertion instructions clear? Can battery changing be done in the dark? Are battery-insertion signs readable?

If the unit has removable power and/or sync cords, can they be confused? Can they be replaced in the dark? (Nonremovable sync cords can be a real problem: when they die, the whole unit has to go to a repair shop.)

If the cords are permanently attached, is there some provision for storing them in or on the unit?

Could the cord connections to the camera interfere with camera operation?

If the unit has a plug-in sync cord, how secure is the fit to the camera's sync plug? Is there any provision for locking?

Is there an open-flash button?

The biter is bitten: Dr. Harold Edgerton sits for his portrait in the electronic-flash commercial studio of Steve Grohe, a Boston photographer. Behind "Doc" Edgerton is a 50,000-watt-second electronic flash tube his pioneering lab invented during World War II. The portrait will be made with the huge 20 × 24 in. (about 51 × 61 cm) Polaroid Land camera at the left, with soft light from the umbrella reflector on the flash head at the center.

Lamp Head Mounting

Is there any provision for mounting the unit on a light stand?

Can lighting accessories, such as umbrella reflectors, be used with the unit?

What is the reflector's beam angle? Does it match the lenses you'd like to use for flash work?

Are any accessories available to widen or narrow the beam's angle?

If the reflector is rectangular, is the beam's coverage the same in both directions? or is it wider in the horizontal orientation? Will this cause problems for you?

Are there any provisions or accessories for mounting the reflector well above the lens to minimize shadows?

Is there any way to mount the speedlight on the camera without using a bracket?

If you intend to use a wide-angle lens with a wide-angle reflector, is there a mounting technique that will let you align beam and reflector angles for corner-to-corner lighting of the picture area?

Is the lamp head, or the monoblock unit, convenient to hold in one hand for off-camera lighting?

Is a PC cord supplied with the monoblock unit? Is it long enough for effective off-camera lighting?

General Utility

Are there any necessary adjustments that are clumsy or difficult to make without tools?

If the unit is powered by removable batteries, is the battery compartment so designed that a corrosion-swollen battery could jam and be difficult to remove?

Is the battery compartment designed to permit easy inspection of battery condition?

Could battery corrosion damage the unit?

Are the batteries easy to insert and remove?

Are charging procedures clearly described for nicad-powered units?

Is there provision for firing a second lamp head?

Can a "slave" photoelectric cell be used conveniently?

Are such options as shadowless ring lights or bare tubes available?

How difficult is it to use a long sync cord for off-camera lighting?

How long a sync cord can the firing circuit accommodate and still fire the unit reliably?

Can the accessories for this unit be used with other makes or models?

If the unit uses expendable fuses, are they easy to replace? Are they widely available?

If the unit uses AC house current for either operation or charging, is there any provision for adjusting it for foreign voltages when you travel? Are prong-conversion plugs available?

Is there an automatic device to turn off the charger after it has finished its task?

New models are always coming on the market. These Metz units, made in West Germany, have many options including alternative power sources, bounce capability, remote sensors, and exposure automation effective up to nearly 15 m (49 ft).

Electrical Characteristics of Automatic Units

What range of ƒ-stops can be used with a given film speed?

If more than one stop is available, which does the unit offer: a choice of specific stops or a continuously variable range?

Will the unit's automatic operation cover all the distances necessary for the kind of photography you expect to use it for?

Are these distances clearly visible? even in the dark?

How close can you shoot with automatic control when using your fastest film? Is this close enough?

Is a remote sensor available? Does it mount conveniently and securely? Can it be used with extension sync cords for off-camera lighting?

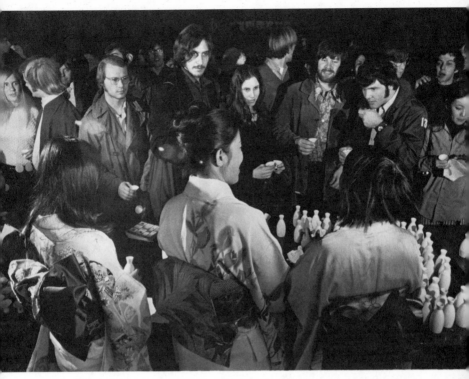

Two bare-tube flash units were used here, one at each end of the table to make a right angle with the camera. The result is that the backs of the three figures in the foreground are kept in shadow and the attention of the viewer is focused on the tasters at the opposite side of the table, facing the camera.

Is there a test flash to verify automatic operation at different distances?

Can the unit be used for automatic operation in daylight?

Can the unit be used for manual, as well as automatic, operation?

Is there a nonautomatic exposure calculator for use when the unit is set for manual operation?

What is the longest recycle time? Can you live with it?

How much do recycle times increase if your batteries are partly exhausted?

How many battery or outside-power options are available?

Is a high-voltage short-recycle accessory battery pack available?

How many flashes can you expect from a full charge or from a set of fresh batteries? Does this seem reasonable for the kind of shooting you expect to do?

Are the recycling times affected by rapid shooting?

If the unit has a rechargeable battery, how many times can it be recharged before capacity and performance start to suffer?

Is the battery charger incorporated into the unit, or is it separate?

How long does it take to charge the battery fully? Is this fast enough for you?

Is a rapid charger available?

Can the unit be used with different types of batteries (nicad, carbon zinc, and/or alkalines)?

Does the trigger circuit leak any current into the camera, putting you in danger of receiving a shock? (This does happen sometimes with cameras that have both a hot shoe and a sync plug on the same firing circuit. Even though a speedlight is hooked into the sync plug, the hot shoe is hot, too, and can give you a mild shock if you happen to be wearing metal-rimmed glasses or if you arch your eyebrow too closely over the hot shoe while using the viewfinder.)

Are there any other places that might give you a shock?

(With some rechargeable units, touching the plug for the AC charging cord can give you a mild but unpleasant jolt of electricity.)

How full is the capacitor when the ready-light goes on?

Can the unit be fired the instant the ready-light comes on, or will it only fire when the capacitor is fully charged?

Can the ready-light be read in bright sunlight?

Is the unit moisture-proofed, or will warm, moist air condense on it when it's cold, resulting in misfirings due to short circuits?

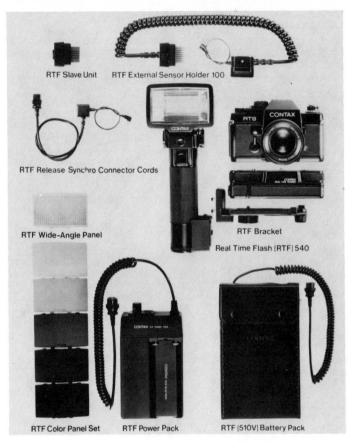

RTF Slave Unit RTF External Sensor Holder 100

RTF Release Synchro Connector Cords

RTF Wide-Angle Panel

RTF Bracket

Real Time Flash [RTF] 540

RTF Color Panel Set RTF Power Pack RTF [510V] Battery Pack

The Real Time Flash 540 dedicated system for the Contax RTS and Yashica FR cameras allows not only autothyristor operation but also through-the-lens flash-exposure control. There is a selection of rechargeable and rapid-cycle power packs and connecting cords for off-camera positioning of automatic flash, as well as other accessories. When you start out in flash photography, though, stick to the basics. Expensive and complicated units may be outmoded before you learn to take advantage of all their features.

Photographic Characteristics

Are accessories available to let you vary the reflector angle?

Are such reflector accessories as netural-density filters for close-up shooting or colored lenses for "effect" lighting obtainable?

Is an incandescent modeling light, by which you can preview lighting effects, available as an accessory?

Bounce flash is often an improvement on direct lighting, but it has difficulties of its own. Here, at a wedding reception, the bounce off the ceiling (notice the highlight above the subjects' heads) gave a halo to the older woman's hair but left her face in partial shadow, and the bride's white dress was overexposed and had to be burned-in in the darkroom to show detail.

Consumer Protection

What's the warranty period on the unit? How does this compare with warranties offered for similar units?

Do you send in the warranty card, or does the dealer?

Can warranty repair work be done locally, or must the unit be shipped back to the importer or manufacturer?

If the latter is true, what's the maker's reputation for turnaround time? (Ask your dealer about his or her experiences with that particular manufacturer or importer.)

Will either the manufacturer or the dealer let you have a "loaner" unit if yours has to go for repair?

Must you pay for a long-distance call to check on the status of your repair?

Are repairs charged at a flat rate? What are some typical rates?

Does the dealer know any other customer who has experience of the unit and/or its service reputation?

Is the unit you're thinking of buying still being made? (If it is an older model, it might be scheduled for replacement. If it is too new, it might have some wrinkles that need to be ironed out.) Is it, perhaps, a close-out bargain, that might cause you service problems later, when parts become scarce?

Is there a notably better unit available for a similar price? a similar unit for a lower price?

Is the unit you're considering a common one that most dealers are familiar with, or is it a rare bird that you may have trouble having serviced when you're traveling?

If the unit uses replaceable batteries, are they an easily available type? Is there a similar unit that uses less-expensive batteries?

Not all these questions can be answered at a dealer's counter, or even after reading up on different units and checking their instruction books. That's why it's so important to trade with a dealer who is willing to cooperate and to let you return the unit if it doesn't perform the way you expected it to. Incidentally, be sure the dealer offers cash refunds, not just credit.

The selection of photographic equipment is a very personal matter. If you have never bought a portable electronic flash unit before, it's probable that only experience will let you know whether you've made the right choice. In the next chapter, we'll show you how to test the new unit to see if it comes up to expectations.

5

The First Roll of Film

When you bring your chosen portable apparatus home, you'll want to do the things you couldn't try at the store. Your home testing should be basic but stringent.

What kind of film do you test on? Your best bet would be a medium-speed color film, such as Ektachrome 64 or Fujichrome 100, that delivers a transparency, or "slide." Unlike either black-and-white or color negative ("print") films, color-slide films are not very tolerant of exposure vagaries. For this reason, if the unit isn't giving the right amount of light you'll know it on the first roll you see. Also, these films can be processed by many local color labs in a few hours—you'll be able to see the results right away. The sooner you see your mistakes, the faster you will stop making them.

START AT THE BEGINNING

Go over the instruction book thoroughly. Check out the pointers on battery insertion—or on charge, if the power cell is built in. Be sure the unit has the power to operate effectively. The capacitors of new flash units or ones that haven't been used for awhile will need to be "formed" to bring performance up to standard. This is done by running current through the unit for a period of time—follow exactly the details in the instruction book.

Read the instruction sheet for your flash unit carefully. Familiarize yourself with its features even before you load up the batteries. This is common sense with any new piece of equipment, but it is particularly important to take good care of a unit you may want to return to your camera store if you don't like the way it performs.

Load your camera (you'd be astonished how many photographers forget!) and verify that it's in operating condition by checking out the battery, if it has one. As we've said, battery failure is the Number One cause of camera failure as well as of flash failure.

Set the Right Shutter Speed

Next, find out which shutter speed will synchronize with your flash unit. On most 35mm SLRs the appropriate speed is indicated by either having the number in red or adding a tiny lightning flash on the shutter-speed dial. You'll notice that this is usually a relatively slow shutter speed: 1/125 sec. at the most, more usually 1/60 sec. or 1/80 sec. The explanation is that only at these slow speeds (or slower) will the focal-plane shutters most of these cameras use be *fully* open. Higher speeds result in frames that are partly blank.

If you happen to have a leaf-shutter camera, such as a twin-lens Rolleiflex or Mamiyaflex or the single-lens Hasselblad or Bronica, synchronization is much more

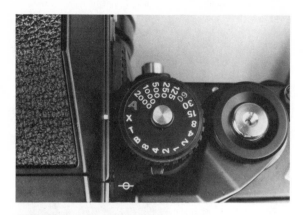

Leaf shutters (left) allow M-X sync at all shutter speeds. "M" is for "medium-peak" flash-bulbs, "X" is for electronic flash. The "X" shutter-speed setting on the Nikon F3 (above) is the fastest at which the entire frame is exposed at one time by the camera's focal-plane shutter—about 1/80 sec. If used for synchro-sun work at action-stopping speeds outdoors, it will give "ghost" images.

flexible. Leaf shutters, unlike focal-plane shutters, are always either fully open or fully closed, no matter what the shutter speed. As a result, flash can be synchronized at *any* shutter speed. While this may not be significant in most indoor work, it's very advantageous when you use flash light outdoors to fill in sunlight-caused shadows that would otherwise be excessively deep—a technique called "synchro-sun," which we'll be getting to later (Chapter 8). Leaf shutters usually have adjustable "M-X" synchronization: The "M" is for use with medium-peak flash bulbs (such as M5s and M25s) and the "X" for nondelay speedlight synchronization. If you don't use the "X"-sync for electronic-flash shooting, you won't get any picture at all. The electronic flash will go off all right on the "M" setting, but not necessarily when the shutter is open—the shutter and the light will not be synchronized.

Make the Connections

Once your camera is loaded and the shutter set for the correct speed—one that will guarantee that the shutter will be *fully* open when the flash goes off, mount the unit on the camera. Use either a bracket or a shoe. Shoes are either hot or cold. A cold shoe will attach the speedlight to the camera, but you will need to plug a sync cord into the camera's "X" terminal. A hot shoe incorporates this electrical contact and does not need an external connection.

If you are using a sync (PC) cord, plug it in and make a test shot to see whether the unit fires. If it doesn't, make some checks:

• Were your batteries fully charged? Are they inserted correctly?

• If you are using primary batteries, did you verify their freshness with the camera store's battery tester?

• Has the unit's on/off switch been turned on? (You'd be surprised how many people forget.)

• Have you checked your sync contacts? If you're using a hot-shoe mounting, was the unit inserted right side to?

PC cords that pop out of sync plugs are a constant problem. Adding a threaded tip to PC cords is a major advance in this weak electrical link of portable flash operation.

• If you're using a sync cord, check the condition of the camera's PC plug.

• If the flash still doesn't fire, try a different cord. Batteries and sync cords are major bugbears of speedlight shooting and account for most nonperformance in new units.

Illuminating this newly enlarged family in a tiny living room called for bare-tube strobe, the only light source that could handle the wide angle of view of the 20mm lens. The author balanced on a kitchen stool with one bare tube over the camera; a second tube was slaved and set on a stand behind the parents, to give them a halo while lighting the other children.

EXPOSURE PREPARATION

Now, set your exposure. With a manual unit, the first test roll should be used to determine a guide number under the conditions you expect to encounter most often in your photography. If you plan to make many pictures in the living room, for example, do your testing there. Choose a subject you'd be likely to photograph—perhaps a friend—and place him or her some ten feet (three meters) away from you and the speedlight-equipped camera. Make a series of exposures, ranging from the largest to the smallest f-stops on your lens at one-stop intervals. For each shot, have your subject hold up a card with the flash-to-subject distance and the f-stop written on it, so that afterwards you will know that information just by looking at the pictures. When you get the film back, project the slides and study them. Which one was at the correct exposure? Take the f-number that produced that shot and multiply it by ten (your distance, in feet). That's your guide number for that film for direct flash with that unit under conditions similar to those you were shooting under. Does that sound complicated? It's not, really. For example, if your best-exposed picture was shot at $f/11$, your guide number would be 110 for film of that particular ISO/ASA/DIN rating whenever you used that flash unit indoors.

It might interest you to compare your custom-determined guide number results with those of the camera's manufacturer-calibrated exposure calculator. You'll probably find your test shows that the manufacturer was more optimistic in evaluating the unit than he should have been. However, if you figure out the precise gap between the calculator's exposure and your tests, you can adjust the film-speed setting in such a way that you will be able to use the calculator for correct exposures at different film speeds without any more testing (when you shoot *under conditions* that are like your testing conditions). This is not hard to do.

Adjusting Manual Flash Calculators

If the unit's calculator shows a one-stop underexposure at a given distance for a given film speed in comparison with

the exposure your tests have determined, drop the calculator's film-speed setting one stop. This will cut the film-speed setting in half; the resulting exposure calculations should be consistently accurate. That is, if the unit's calculator has been telling you to set exposures you think are one step under, you can compensate by changing the film-speed setting. For example, change an ISO 100/21° rating that is giving you underexposures to ISO 50/18° or ISO 400/27° to ISO 200/24°)—the result should be correctly exposured pictures.

A bare-tube flash unit on a stand behind this kick line (the stand shows between the second and third dancers from the left) flooded the background with the bare-tube flash's characteristic "blob of light." A second unit on a stand to the right of the camera illuminated the women from the front. The photographer lay on the floor, directing the rehearsing amateur performers and using a 35mm SLR with an 18mm super-wide-angle lens.

Adjusting Automatic Flash Calculators

With automatic-exposure units, the procedure is different because the unit is expected to do all the exposure calculations for you.

First of all, set the rated speed of the film you're planning to use in the appropriate spot on the unit's exposure control. This setting should also operate the distance-range indicator, which will show you the nearest and farthest distances from the unit at which subjects will be correctly exposed. Some units offer a choice of ƒ-stops for automatic operation with a given film speed; the distance at which you expect to be working and the depth of field you want in the final pictures will decide your choice.

Now start shooting your automatic-exposure pictures over the full distance range indicated by the unit. Do you find working with this unit convenient? Do its distance ranges agree with the kind of photographs you'd like to take?

LOOK FOR PROS AND CONS

Give some thought to the unit's handling. Does it interfere with the operation of your camera? Can you still focus and advance the film conveniently? Does the normal operation of the unit tend to pull cords loose from sockets? If you're using a bracket, is it comfortable and easy to grip? Does it mount securely to the camera?

How about recycle time? Can you accept the pauses between flashes? If the unit is an auto-thyristor (AT), does its power-saving feature speed up recycle time significantly at the distances you like to shoot at? Remember, the more power you need, the less power the unit can save, and, consequently, the longer the recycle time.

Try out any accessory lenses you have, to see whether the reflector's coverage is wide enough.

In the course of testing your unit you are bound to discover some of the inconveniences of using flash with an SLR. The major one is that, because the mirror is up at the instant of exposure, you don't get to see your subjects during the instant when the flash goes off. For this reason, it's

Shadows thrown by the bounced light from tilting-head flash units can be "opened up" by such devices as the Eye Panel of the Vivitar 3500, seen here in raised position.

advisable to look just *above* the camera when making an exposure. It's a brief flash, but you can notice a lot—such as how many subjects have their eyes closed!

Another problem with SLR flash is not being able to check the depth of field at the moment the flash goes off. This is because you focus and frame the picture with the lens diaphragm wide open for a bright image yet shoot at a smaller setting. Most 35mm SLRs, however, have a depth-of-field preview, so that the user can close the diaphragm down to the taking aperture in order to see how much of the picture is actually in focus. Many flash pictures are of groups of people, and it can be vital to know whether both the front and the back rows of faces are in focus. It can make a difference in how you pose your subjects or compose the picture.

Finally, many flash pictures are taken (naturally enough) in dim light. SLRs focus through the taking lens, and the image seen through the viewfinder may be too dim for accurate focusing. That's when "scale focusing"—also called "zone focusing"—comes in handy. In scale focusing, you first estimate the flash-to-subject distance by eye, then set the distance scale on the camera to where the pointers will include the nearest and the farthest points at which you want things to look "sharp" in the final picture. These limits are governed by the aperture. This is where an automatic unit with a choice of *f*-stops can be very handy: You can set a smaller stop, to get greater depth of field, if you need it.

Don't Shoot Till You're Ready

Now's the time to start learning to make all your focus and exposure adjustments *before* you raise the camera to your eye. Fiddling with your camera at eye level will only create bored, irritated-looking subjects. When you raise your flash-equipped camera to your eye, be prepared to use it immediately.

HOW TO EVALUATE YOUR RESULTS

When your slides come back from the lab, sit down and take time to evaluate them carefully.

1. If you were testing a *manual* unit, what test *f*-stop gave the best exposure? Note this down, for the guide number to use in other, similar situations.

2. If you were testing an *automatic* unit, did it keep giving consistent exposures as the flash-to-subject distance varied?

2A. When automatic electronic flash is used for very close work, the fraction of a second it takes for the light to bounce off the subject and back to the unit's sensor is too short for the electronic circuitry to handle. The result can be overexposure. The unit may be fine for automatic exposure-control at longer distances, and so overexposure at short distances can't really be regarded as a malfunction; but you should understand its cause. Overexposure could be passed off as being due to shooting too close on automatic control, but it will occur even when you obey your distance range scale faithfully. This is a subtle problem with some automatics; but with a bit of experience you can learn to stop your lens down a bit more—as much as one *f*-stop—to compensate.

2B. Sometimes when an automatic unit is used close up, the unit's sensor will not read the lens's field correctly. This is especially likely to happen when you're using a unit whose sensor is offset, that is, mounted on a side bracket rather than in the accessory shoe just above or beside the lens. Since the sensor's angle of acceptance is about 15 degrees, narrower than that of most lenses you're likely to be using, the offset sensor will read the corner of the lens's field of view rather than the center. When a cen-

Synchro-sun techniques are not restricted to sunlit areas—or to professional photographers. This presentation of athletic awards was held indoors. Exposure was calculated for the general over-all light level, then the flash simply filled in the shadowy areas.

ter reading is important, it is best to be sure the sensor is mounted directly over the lens.

3. Did the automatic-exposure results vary with the lighting conditions under which you were shooting? This, too, is a subtle problem with automatics. Suppose you were working in a very brightly illuminated room, shooting flash at the relatively slow shutter speed of 1/30 sec. The automatic-exposure flash unit would read one exposure, for itself only, while, if the room light were bright enough to make an exposure even without the flash's help, the camera would read another *in addition*. In other words, the automatic flash will make a correct exposure without regard for the camera's shutter speed but if the ambient light (i.e., the light already existing in the area where you're taking pictures) is bright enough and the shutter is open long enough, you will end up with overexposure. This should not be considered an equipment malfunction. Rather, it is a flash-related syndrome that you should understand so that you can take the proper precautions. Remember, high ambient light and slow shutter speeds can result in overexposure even when both camera and automatic speedlight are working perfectly.

4. If any frames were underexposed, can you remember firing the unit the instant the ready-light came on? How serious was this loss of exposure? Could you accept it if you had to take pictures in a hurry? Would you have lost the picture if you had waited out the full recycle time in order to get full power and correct exposure?

5. What's the color quality of the correctly exposed pictures? If it's on the blue side, the unit is not doing an effective job of filtering ultraviolet (UV) light, and you'll need a UV filter for your camera lens.

6. How efficient was the reflector coverage? Did it spread light over the whole angle of view of your wide-angle lenses, or not? Did you make this test with the reflector as it was, or did you use a beam spreader to throw light on a wider angle? Did you compare the spreader's effect to coverage produced by the reflector alone?

7. Was the unit convenient to use? How much time did you have to spend worrying about it? Do you think any inconvenience was reasonable in proportion to the benefit of taking flash photographs?

8. Was the unit convenient to carry when you weren't actually taking pictures? Was it top-heavy when mounted on the camera? Did it flop over when you carried the camera–flash–unit combination by the neck strap?

9. Did the unit perform well in all shooting situations, or did its limitations force you to pass up pictures that you would have liked to take?

10. Was the battery capacity great enough to allow you to shoot the number of pictures you wanted to? If not, could the unit be run on AC house current while the batteries charged up? Are extra batteries expensive?

If you have answered most of these questions positively, congratulations—you have a winner of a portable electronic flash unit.

Properly used, filters can give intriguing effects. To produce this normal-colored foreground against an odd-colored background, a pair of color-complementary Cokin Color-Back filters was used: A yellow filter was placed over the lens, a mauve one over the flash head. The two filters cancelled each other out for the foreground figure, giving normal color rendition, but the background—where the flash did not reach—was yellowed by the lens-mounted filter. Other combinations of Cokin Filters produce different colors or effects. As with all special-effects equipment, make sure use of the effect will really improve the picture in a logical, meaningful way. (Photo, courtesy of Cokin)

97

A pair of stand-mounted portable electronic flash units faced
each other midway between tree and camera. The result, an
evenly illuminated area from the camera to the background, was
verified by a Polaroid Land camera shot. A flash meter determined
the final exposure. One flash was fired by the camera's sync con-
nection through an extension cord; the other was slaved. Expo-
sure was at f/11 on Ektachrome 64 film; a 24mm lens was used on a
Nikon F2 camera. Notice that the younger child (foreground) is
looking at the lights instead of at the camera, making a better
document of a real occasion.

Above: A stand-mounted electronic flash unit at far right lighted the side of computer and the woman operating it, plus the deskful of paperwork and the face of the man in the foreground. A second unit, out of sight to the left of the camera and slaved to the first by a photoelectric cell, lighted the man's back. Since interior and exterior illumination in this sunlit office had to balance, a lot of Polaroid testing and repositioning of lights was done.

Right: A single flash unit on a long extension cord was set up to the right about 3 m (10 ft) from the paper trimmer at a printing plant. This distance kept exposure reasonably equal over both the machine and the stacked paper in the foreground. The operator's face was left in shadow but silhouetted against the bright frame of the machine.

Above: *On-camera flash is the easiest, most common flash technique—and the worst. The dead-flat light makes skin look spotty, greasy, or unhealthy. Usually there's an ugly black shadow on the wall to one side of the subject. Eyes look stark and sometimes have the orange glint of "red eye."*

Above: *Ceiling-bounced flash avoids the harsh glare of direct flash, but it has problems of its own: In bouncing down from overhead, it throws shadows under eyebrows, cheeks, and chin. Furthermore, although the ceiling looked white, it obviously had a touch of warm color in it—see the unexpected yellow-orange color-cast.*

Left: *Stand-mounted flash bounced off an umbrella took more time, trouble, and equipment than the other two—and produced superior results. The light, coming from the left at eye level, illuminated both background and foreground with neutral low-contrast light, and the shadows look appropriate.*

Above: *This charming Chinese gentleman was a Justice of the Peace in Brighton, Mass. The omnidirectional light from a bare-tube slave flash unit on a stand halfway between him and the wall at the left lighted the entire colorful living room. Another, at low power, was held above and to one side of the camera.*

Below: *Three light sources were used: A bare-tube flash unit flooded the background wall with light; an umbrella setup on a stand to the right of the camera illuminated the molecules; a second umbrella unit, on the left, highlighted the researcher's face.*

Opposite page: *King Lear and his Fool were shot for theatrical publicity using an electronic flash studio unit with three heads, all mounted on stands: the main light to the right of the camera; another to the left, angled toward the camera to light the back of Lear's head; a third for the background (barely visible in this frame). Pictures like this need only be posed for composition, not for the precise expressions. The subjects kept on performing while two rolls of Kodachrome 25 film were shot at f/22 (85mm on a Nikon camera). The result was 72 needle-sharp color slides to choose from.*

Below: *This "speeding" car was actually standing still. The shot took two exposures, two light sources, and a zoom lens. A camera with an 80–200mm zoom lens was set on a tripod in front of a parked car with flashing lights. An electronic bare tube, connected to the camera by a 50-foot sync cord, was placed inside the car to light the driver. Flash exposure for Ektachrome 64 film was metered at f/11, and that aperture was set on the camera. The shutter was then opened for five seconds, during which the lens was zoomed over its entire range. The result was a single sharp image of the driver from the flash inside the car and blurred streaks from the car's lights as the image changed size while the lens was zoomed.*

Three stand-mounted flash units were used to record this metal-anodizing plant. The one to the right and about 3 m (10 ft) ahead of the camera shone on the wall in the background; "slopover" from this also lighted the background anodizing tanks. A nearby unit illuminated the right side of the carefully posed operator and the rack of metal parts being hoisted over the anodizing tank in the foreground. A flash, from the left, opened up shadows cast by the righthand units. Exposure was at f/4; 21mm wide-angle lens on Nikon camera; Kodachrome 25 film.

Holding the flash unit above the camera kept the man in the background and the plate of food in the foreground about equally distant from the light source. The result is an evenly exposed picture even though the different elements were at different distances from the camera.

6

Get All You Can From One Light

When photographers think of flash photography with one light, mostly they think in terms of one light mounted on the camera. The majority of pictures made by portable flash units do use this basic technique.

ON-CAMERA PROBLEMS—AND SOLUTIONS

It may be convenient to mount your speedlight on the camera, but this method doesn't necessarily produce the best pictures. Let's see why.

 • On-camera flash gives harsh, contrasty, unflattering light.

 • Evenly exposed pictures are difficult to achieve when subjects have much depth (as is true, for example, of groups, or in rooms full of people). As the distance from flash to subject increases, the light from on-camera flash drops off rapidly; this results in dark backgrounds and chalky, overexposed foregrounds.

 • Automatic-exposure units can be fooled by light reflected from a foreground subject, cutting down the exposure and leaving the background hopelessly dark.

 • When the on-camera flash is mounted too close to the camera's lens, "red eye" occurs. This effect is seen when light from the flash goes straight through the pupils

While a single flash unit is convenient, it produces flat front lighting, which is not always flattering to the subject.

of subjects staring directly at the lens, picks up the red of the blood vessels inside the eyeball, and reflects straight back through the lens to color film. The result is a red-orange glint in the subjects' eyes in the final picture.

Still, on-camera flash is so convenient that people are going to use it whether or not it gives top-notch results. That being the case, here are some tips for better pictures.

• Keep all subjects in one frame at equal distance from the camera-mounted flash, so that all get the same exposure.

• Pose your subjects in front of a wall, whenever possible. This will avoid the dead black backgrounds common to on-camera flash. Note, though, that this technique will make shadows from the flash more noticeable unless the people are a few feet out from the wall and the unit is held directly above the lens, so that the shadows fall behind the subjects.

• To prevent "red eye," hold the flash unit above the camera rather than close to the lens. This will keep the light from beaming directly into the subjects' eyes and back to the film. Also, tell your subjects not to look directly into the camera. This will cure red eyes no matter where the light is placed. Then, too, you can ask your subjects to look briefly into a bright light (such as a table lamp). This will cause the pupils of their eyes to close down. Red eyes are most common when subjects are photographed by flash illumination in places where dim light had caused pupils to dilate.

107

The low contrast of bare-tube flash makes it a useful close-up light. The light-colored dresses of the bride and her attendants retained detail because they were not overwhelmed with a blaze of light.

If the subject is standing near a wall, an on-camera lighting unit may throw heavy shadows beside the subject's head. To prevent this, use a bracket or simply uncouple the unit and hold it well above lens level.

• If you want to pose your subjects in front of such shiny surfaces as mirrors or windows, don't stand directly facing them or the light will be reflected back in a bright glare. If you *must* pose subjects in such surroundings, try to work at an angle to the shiny surface, so that the light will be reflected in a direction away from you.

• If you're shooting a group of people, or a scene with a good deal of depth, try to move as far back as possible, using a longer lens. As a result, the distance from the front to the back of the group will occupy a smaller proportion of the total flash-to-subject distance, and so light drop-off will be less abrupt and the exposure will be more even over the entire group. A flash unit with a variable-angle reflector can be useful here; it can funnel all the light into a narrow beam to carry the longer distance necessary with the longer focal length of the lens.

THE NEXT STEP: BOUNCE FLASH

The easiest step beyond on-camera flash is to bounce the light by pointing the reflector at a light-colored surface (usually a white ceiling or wall) that will in turn reflect the light onto the subject. Benefits include wider light distribution and lower contrast. The popularity of bounce light is attested to by the number of portable speedlight units now on the market that have tilting and rotating reflectors, which can be pointed in a variety of directions. The direction chosen will depend on the relative position of the most convenient reflective surface. While no additional equipment is really necessary for bounce-flash technique, a sync cord will allow the unit to be held in the hand and pointed at reflective surfaces *independent* of the camera's position. The result is a consistent light source—which is never the case with a camera-mounted movable-reflector unit that changes its position in tandem with the camera.

Limitations of Bounce Flash

Bounce flash is the first variation of lighting technique most photographers try once they've become accustomed to on-camera flash. It has limitations as well as advantages, though, and you should be aware of them.

When light is bounced off the ceiling, deep shadows may result under eyebrows and chins. A couple of fingers held up behind the reflector can redirect just enough light to counteract this and create bright "catch-lights" in the subjects' eyes.

- Bounce flash is most effective in small rooms, where the power of the unit won't be dissipated by distance from the reflective surfaces.

- Very small speedlight units don't have enough power to expose a bounce-light picture on any but the fastest films.

- Determination of exposure is difficult with non-automatic units. Since size of the room and reflectivity of the walls have a direct effect on the usable light, exposures can't be figured by guide numbers. The only effective way to arrive at the correct f-stop is to use an exposure meter made especially for use with flash equipment.

- On most small automatic-exposure speedlights the sensors point in the same direction as the reflector. This means that they read the surface from which the light is bouncing—which is not necessarily the area the camera

is photographing. While automatic exposure is the most convenient way to get accurate bounce-flash exposures, a remote sensor is definitely advisable if you want to use this technique effectively. Some units combine a sensor built into the body of the unit with an independently swiveling reflector; this arrangement is not really satisfactory because the reflector's orientation is still based entirely on camera position.

• If you are using color film, colored walls and ceilings will affect the bounced light and, naturally, the final photograph: The flash will pick up the color of the walls it is reflected from. Bounce flash works best in white rooms: They not only give the best color but also reflect the most light.

• While the most common procedure is to bounce the light off a white ceiling, the results are a mixed blessing: The room is illuminated more evenly than it would be by direct flash, but most of the light comes from above and there are deep shadows in the eye sockets and under the chins of any people in the room. A number of units have a second flash tube with a small reflector to fill in these under-eye shadows. The second reflector always points in the same direction as the camera's lens when the unit is mounted in an on-camera hot shoe. (The Toshiba ES-T30L and the Continental XF 300 Twin are models currently offering this dual-reflector system.)

A simpler way to prevent the dead-eye look of bounce flash is to add a small reflective surface near the reflector. This will catch spillover light and redirect it to put a spark, or "catchlight," in the subject's eye. One classic technique is to tape a 3×5 file card to the back of the upward-pointing reflector. Some experienced photographers have found that a couple of fingers held up behind the reflector will have a similar result.

Some Refinements

Sophisticated variations on the simple white cards just described are made for flash units that have tilting heads, such as the Popular Litematic 38TG High Performance Auto-Thyristor System Flash (from Morris-Toshiba) and the Soft Light/Bounce Diffuser Kit (from Vivitar). These

have cards mounted on brackets over the reflectors at a 45-degree angle. The reflectors are then turned upward, so that their output is directed onto the cards. The result is a camera-mounted unit that delivers lower contrast and wider coverage than a direct flash does, yet does not need a ceiling or wall to bounce from.

A ambitious approach is that provided by the Larson Soff Shoulder. This device has a small folding umbrella of reflective cloth, brackets for mounting a flash unit to aim into the umbrella, a brace to hold it all on the photographer's shoulder, and a camera-mounting bracket. It's effective, but it is clumsy to carry. (More about umbrellas in a moment.)

The Novacon Strobo Frame makes a slightly less bulky low-contrast light source. It supports a flash unit above a bracket-mounted camera. The light passes through a special diffuser.

Bounce Umbrellas

Long a professional standby, umbrella lighting delivers a soft light particularly effective for color photos of "high key" (i.e., light-colored) subjects. This low-contrast lighting is achieved by bouncing flash output off a stand-mounted umbrella made of special reflective cloth. Bounce umbrellas are available from dozens of manufacturers and can be found in most large camera stores. Besides the portable version mentioned above, Larson's line includes various types of mounting equipment to enable you to mate your speedlight, the umbrella, and a light stand into a single unit. The umbrella absorbs some of the speedlight's output, and the combination of automatic unit and camera-mounted sensor makes for convenient and accurate exposures.

Simpler and more portable answers to the need for wide-angle low-contrast light are provided by such ingenious inventions as the Air Diffuser and the Air Brella (from New Ideas, Inc.). These accessories consist basically of inflatable plastic bags that snap over the reflectors of most small portable speedlights. The former is a diffuser; the flash unit's illumination is directed *through* it to give a low-contrast, gentle light. The latter, the Air Brella, is half

Bounce umbrellas can be mounted on stands or on the camera, like this small device designed for Sunpak portable flash units.

clear and half opaque, forming what amounts to a small inflatable bounce umbrella: The flash is directed through the clear section to bounce off the white section. Both these accessories are inexpensive and easy to carry when deflated; they can be used with either manual units or automatic units that have remote sensors.

With any of the devices mentioned above you can get bounce effects without the need for special reflective surfaces. For example, using a long sync cord, have an assistant hold the diffused light off to one side of the camera, but pointing at the subject. This angled illumination will bring out depth and texture that a camera-mounted flash could not show because it cannot throw shadows *across* a subject, only *at* it.

Check the Angle

As long as the limitations of bounce flash are understood along with its capabilities, impressive results are possible.

Larson Enterprises offers one of the largest selections of umbrella reflectors on the market. Their Quikmount hardware permits mounting of portable lamps singly or in pairs, or with a modeling light.

Always remember that the angle of incidence is equal to the angle of reflection. In other words, if you direct a beam of light against a reflective surface from a 45-degree angle, the light will be reflected (bounce off) at a 45-degree angle: making a total 90-degree angle for the light to travel. Does that sound too complicated? Try this approach: Imagine throwing a basketball at that reflective surface and imagine what direction the basketball would travel when it bounces off that surface. Notice that it will always bounce off at a right angle from the point of impact. Light behaves in more or less the same way.

What does this mean in practical terms? If you want to light someone standing in the middle of a white-ceilinged room with bounce flash, stand at one end of the room, point the flash unit's reflector at the ceiling at the midpoint between light and subject, and fire the flash. The light will strike the ceiling and bounce at a 90-degree angle back down onto your subject. The procedure is the same when you bounce the light off a white wall—only the angle is sideways rather than upward. When using flash, imag-

ine that your reflector is a hand throwing a ball (the light) and your subject's the target spot where you want that ball to end up.

Look for a reflective surface about the same height as the subject (like a white wall). If there is none in the vicinity, improvise with a white window shade or tack a sheet to the wall. Point your speedlight at this reflective surface—not at the subject. Figure out where the light will be once it's bounced off the reflector (try using a regular light bulb or a flashlight to see the effect). Pose your subject at that point.

Modeling Lights

Anticipating lighting effects is one of the biggest difficulties in flash photography. A useful but, sad to say, rare accessory for portable flash units is the modeling light. This is an incandescent bulb, mounted in the reflector along with the flash tube, that throws light in the same direction as the flash tube and so lets the photographer see in advance exactly where the flash illumination will fall.

Modeling lights are standard with plug-in studio electronic flash units. Unfortunately, they can only operate on house current, and this limits their usefulness with portable devices. The only exception is the nonautomatic line of Lumedyne flash units made by Novatron of Dallas. Spiratone does supply a clip-on modeling light for their Spiralite flash units, but it must be plugged into house current, and this restricts it to indoor use.

Evaluate Your Surroundings

Some places are simply not suitable for bounce flash.

• Large rooms with high ceilings dissipate most of the light from a small flash unit before it can bounce back to the subject.

• Rooms with dark walls, ceilings, and/or hangings tend to absorb light rather than to bounce it.

• In rooms with lots of windows, light tends to escape instead of bouncing back to the subject. If you want to take pictures in such a room, see to it that the shades are light colored and closed.

• Rooms with colored walls not only absorb bounce light but also change its color.

BARE-TUBE FLASH

The technique of bare-tube flash seems to be rediscovered every few years by photographers who try it, like it, tell their friends about it—and then it disappears once again because of indifference or lack of information on the part of the majority of photographers. This is unfortunate. Bare-tube flash is one of the most useful methods of flash lighting available in the right circumstances.

A bare-tube flash is just that: a reflectorless unit that throws its light in all directions.

Advantages of Bare Tubes

Why should anyone want a flash device without a reflector?

• As there is no reflector, there is no restriction on beam angle. The bare tube flashes light over a field of view wider than that of even the widest-angle lenses. It is useful when you shoot in crowds with a wide-angle lens.

While bare-tube flash is a specialized lighting tool, it can be preferable to built-in reflectors for such situations as wide-angle close-ups where low-power fill-in flash is needed. This customized unit, shown on a stand with its power pack, has a removable slave cell on top beside the supplementary bare tube.

• The light from a bare tube has low contrast because there is no reflector to focus a beam. It is ideal for close-ups.

• The bare tube is small, and so it can be included within the picture area without causing serious flaring of light inside the lens. This is helpful in tight quarters.

• A bare-tube flash will let you take maximum advantage of a light-colored room. If you put a bare-tube flash in one corner on a high light stand a few feet short of the ceiling, it will flood the room with even, low-contrast illumination that reflects off walls and ceiling. You will not have to worry about reflector coverage, and if the tube shows in the picture it will not cause flare.

Shortcomings of Bare Tubes

Despite its advantages, bare-tube flash has limitations. It is not an all-purpose tool.

• For most applications, a bare tube is strictly a close-up light: Its intensity drops off sharply beyond five feet (1.5 meters). Still, many close-up pictures are made within this range.

• Unless the bare-tube unit is used within light-colored surroundings, most of the light will be lost.

• Since the bare-tube's effect is so dependent on the reflectivity of its surroundings, exposures are difficult to calculate without a flash-exposure meter or automatic exposure control on the flash unit.

• With automatic-exposure bare-tube units, however, there is the possibility that spillover light will strike the remote sensor and cause false readings, resulting in inaccurate exposures.

• The exposed flash tube is easy to damage.

Bare-Tube Suppliers

The major problem with bare-tube flash units is that there are very few on the market. Rollei of America will modify one of their Honeywell model 800 units to order by adding a bare-tube plug. The unit can then be used for either conventional reflector lighting or bare-tube lighting at the flick of a switch. The custom modification isn't cheap—it

This factory-modified Honeywell model 892 allows a choice of reflector or bare-tube flash at the flick of a switch. The tube is delicate and should be removed for safekeeping when not being used. The low contrast and unlimited angle of coverage of the bare tube offer an alternative quality of light to the more contrasty reflector flash.

can cost around $75. The new Rollei Beta Flashes, models 5 and 6, offer a bare-tube mode (as well as illuminated digital readouts of film-speed settings and distance-range indicators). Rollei has also made a few of its E36RE flash units in a bare-tube version.

Graflex, Inc., supplies bare-tube heads for its 250 and 500 Graflite Strobomatic units, as does Spiratone, Inc., whose Spiralite flash unit is available in a "BB" (bare-bulb) configuration. The reflectors on the Lumedyne N200 unit from Novatron of Dallas and the Norman 200B from Norman Enterprises can be removed for bare-tube use. The Hico-Lite (made by the Hico Corporation) has a bare-tube head available as an accessory.

OFF-CAMERA FLASH TECHNIQUES

Mounting your flash unit elsewhere than on the camera will permit creative effects not obtainable in any other way. All you need is a light stand and a long sync cord.

Light stands look a bit like music stands and are made by many manufacturers. They will hold a flash unit at a set position. Both the Soligor Bounce Head from AIC Photo and the Strobe-All from Spiratone are useful for mounting most small shoe-mounting speedlights on a stand.

A long sync cord is a must if you are to connect your camera to a stand-mounted speedlight unit. An ordinary household double-strand extension cord will work. It is not only cheaper than a factory-supplied sync extension cord but also more efficient. Most manufacturer-supplied extension sync cords are made of lightweight wire to make them easier to carry. This wire presents a greater electrical resistance to the weak currents of most flash-unit trigger circuits, and so these cords work only in short lengths— their limit is roughly ten feet (about three meters). But household wire is a heavier gauge and can carry a trigger circuit much farther—a distance of 40 feet (12 meters) or more.

Ready-made extension sync cords are compact and convenient. Their light-gauge wire, however, may limit the length of cord that can operate reliably. An ordinary household extension cord makes an acceptable alternative.

If you're in the mood to spend some money in return for extra-convenient tripping of off-the-camera flash, give some thought to the Hawk Remote Control (from Hawk Photo Systems). A similar device is available from Wein Products. These are radio-flash actuators that allow wireless tripping of speedlight units at distances up to some 150 feet (about 46 meters). You just plug your sync cord into a pocket-size transmitter and mount the receiver on the speedlight unit. A wireless flash actuator that uses infrared light instead of a radio signal is available from Studio Technik USA. A note of caution: Check the laws in your area before investing in any radio devices.

Off-Camera Dedicated Flash

Users of dedicated speedlights face a special problem when trying to shoot off-camera flash: A regular extension cord will not make the special electronic connections between camera and speedlight. One solution is to use a Duo-Sync cord, available from New Ideas. This is a coiled extension cord for flash synchronization. Different models are supplied for different dedicated-flash systems. They preserve dedicated flash functions while allowing the units to be used off the camera. Two of these cords can be combined, either to fire two different units or to add up to a longer extension.

Single-Flash Portraits

Off-camera flash lighting is far better for portraits than on-camera direct flash. Start with the ideas below, then let your imagination loose.

1. Put the flash on its stand at about a 45-degree angle to your subject. Prop a white cardboard reflector near the shadow side of the subject's head to redirect some of the flash and lighten (or "fill") these shadows. Make sure that the large shadows thrown by your light (such as, of the subject's head) fall outside the picture area. You can also do this kind of picture with a bare-tube flash. If the room is light, it will give a high-key effect.

2. Mount your light high behind the subject and slightly to one side, facing *toward* the camera. Prop a reflective white card just below the camera. The flash will outline the subject's hair with a bright halo, while the white card below the camera will reflect the light back into the subject's face, producing a glamorous effect.

3. Pose your subject with the light at a right angle to the camera. You will get a dramatic sidelighted picture with a dark background.

This picture of a belly dancer and her accompanist was only one of many possibilities in this situation (see next page). Here, the main light was to the left and fill-flash was on the camera.

The dancer was illuminated with one slave flash for cross-lighting and a bare-tube flash on the camera for shadow-fill. Since the performance situation was not under the photographer's control, there was no way to avoid distracting background elements, such as the audience, except by concentrating the light on the entertainers. Variations in printing offered some chance of control, later, in the darkroom.

Portable flash units usually will get you a picture, but when you have to work without a modeling light there's still an element of chance as to just what picture they will get.

OTHER SINGLE-FLASH TECHNIQUES

If you're photographing a group, mount your flash unit high on a stand and pose the group so that everyone is about equally distant from the light. Choose a camera position that gives you good composition. You'll find that this equal lighting produces group pictures with a strong effect of depth and without chalky foregrounds or dark backgrounds.

Remote flash can be used to fake effects. For example, putting the flash unit in a fireplace with orange cellophane over the reflector can give the appearance of firelight. A flash unit placed outdoors and shining through a window can simulate daylight long after sundown.

When you're doing off-camera lighting with a nonautomatic unit, remember that exposure calculations are based on the *lamp*-to-the-subject distance not the *camera*-to-subject distance. Use the camera-to-subject distance only when the speedlight is mounted *on* the camera.

Painting with Light

A useful technique for lighting up large areas with a single flash unit is called "painting with light." It only works in darkness with stationary subjects. This is how to do it.

1. Set up your camera on a solid tripod.

2. Compose your picture. It usually will be something big, like a house.

3. Open the shutter—and leave it open. Use the "T" (time-exposure) setting on your camera if there is one. If not, use a locking cable release and the more common "B" (bulb) setting.

4. Walk around the subject, illuminating different parts of it with your flash unit, which you carry with you and fire by means of the open-flash button. Be certain to check your guide numbers or your automatic-exposure test light to make sure how large an area your unit is powerful enough to cover at each flash.

5. Go back and close your camera's shutter when you have finished.

Set the camera on a tripod, open the shutter, and use the open-flash button on your unit to set the light off independently of the sync circuit. This is the way to "paint with light". A 4 × 5 view camera was used for this example, the aperture at f/11. Polaroid Type 55 P/N film allowed exposure and composition to be verified on the spot. Three big No. 50 flashbulbs were fired from a hand-held flashgun, as follows: one for the front of each railroad car, one for the side of the modern car (from hidden spot behind the antique one).

6. The final result will give the impression that all the flashes went off at the same time. This technique is used by industrial photographers who have to light up an entire factory at night. (They use the large No. 50B flash bulbs.)

By the way, the procedure is best done in dark-colored clothes. If you wear light ones, you might end up with a lot of pictures of yourself—one for every time you fired off the flash you were carrying! (Of course, that could be part of the fun.)

7

Multiple Flash

When you use more than one flash unit to take a picture, you improve your chances of doing two mutually exclusive things: taking better pictures under certain conditions, and making more mistakes under almost *all* conditions! Before you start thinking about going beyond single flash, therefore, be certain you need to.

A flash meter was used to balance all the light sources in this portrait of a man at home. One slaved bare tube, hidden by the subject himself, fired when the bare-tube attachment at camera position went off. The lens was a 15mm Zeiss Hologon at f/8, on a Leica camera.

START WITH ONE LIGHT

As we've seen in the previous chapter, a single flash can do a lot. Taking the flash off the camera and adding an extension sync cord and a light stand, at the most a $50 investment, vastly increase the utility of the single speedlight. Umbrella reflectors and other diffusers allow you to control the contrast (quality), as well as the direction, of the light. Many successful photographers have never gone beyond the single flash during lifelong careers. Mastery of the capabilities of the single flash was all they needed; more equipment would just have gotten in the way of the pictures they wanted to take.

Single Flash Can't Do Everything

Nevertheless, single flash has definite limitations.

• When you want to light areas at different distances from the light source, you'll find that the tendency of light to drop off quickly once it leaves the flash means that only one spot can be illuminated at a particular intensity. A classic example is the situation where there is a person close to the camera and a room in the background that you want to be seen clearly. With a single flash, it would be impossible to keep the lamp-to-subject distance the same for both foreground and background, the person and the room. If you use two lights, however—one for the foreground and one for the background—it should be fairly easy.

• Several flash manufacturers make sets of color filters that fit over flash-unit reflectors for interesting lighting effects. If you are using two or more units to illuminate your picture, consider using different colors for each unit (but only if it seems to make sense for the picture you're taking).

• When you have an area too wide to illuminate with a single flash, two or more lights can break it up into manageable parts. Photographers who photograph large groups will often find the job easier with a second light source.

• When you need differential lighting to create a mood, multiple lights allow easier control. For example, in

Three flash sources were used here: one on either side of the subject's head (the one at the left pointing slightly forward), and one over the camera to "open up" the shadows thrown by the other two, stronger, units. The skin texture revealed by the forward-pointing light adds a touch of the "masculine look" usually associated with more extreme lighting ratios.

doing a portrait, it may make sense to give more light on one part of the subject's face more than on another. This is easy if you use two lights of different intensities.

• Multiple-source lighting allows you to emphasize shapes and textures more easily than does single-source

lighting. Cross lighting (placing a light on each side of your subject, both lights at right angles to the camera), for example, gives an effect of three-dimensionality that a single light cannot achieve.

This carefully posed scene of city clerks packing up ballots in preparation for Election Day was illuminated by two portable flash setups. A bare-tube flash for the foreground also reached the left side; a direct flash in the background, hidden by the standing man was tripped by a slaving device. A 20mm lens was used on a 35mm camera.

Choosing a Second Unit

Simply stated, multiple flash means more than one unit. What should your second unit be? The odds are you'd do well to buy another of the kind you already have. Two flash units aren't necessarily twice as good as one. More often than not, they're just twice as much trouble to use. So do what you can to make it easy for yourself.

• If you are familiar with the unit you won't have to go through a second getting-acquainted period before becoming proficient in its use.

• It makes sense to buy a unit that can serve as a backup to the one you already own, in case one has to go for repairs.

• If you have any accessories for your unit—wide-angle beam spreaders, brackets, color-effect filters, and so on—it makes sense for them to be usable with any new unit you acquire.

INTRODUCING SLAVES

What makes that second unit go off when you want it to, that is, at the same time the other one does? According to the theory of multiple flash, *one* unit is fired by the sync circuit in your camera. This is called the *master unit*. The *other units* are the *slaves*, so called because their firing is dictated by the actions of the master unit.

Slaves can be synchronized in two ways. The first is to run a sync cord from each unit to a central plug that in turn is hooked into the camera's sync circuit. (Multiple PC plugs for the purpose are available from Rowi and Stitz.) This technique, however, may be more trouble than it's worth. You may wind up with a tangle of long wires and vulnerable connections that can easily fail at precisely the wrong moment. Furthermore, all the units must match: Different models use different trigger-circuit voltages, and if you mix them up you'll guarantee misfirings, spontaneous firings, or no firings at all.

The more common and convenient method of slaving speedlights is to use a photoelectric slave cell. This is a

Some slave cells: Wein Micro Slave plug-in cell (left), Novatron Slave (center, foreground), and GVI Master Slave (center, background). The "cheater cord" (right) allows slave cells with two-prong contacts to be used with units made for PC-cord connections.

A special plug was custom-installed atop the Honeywell 65D flash head (right) to allow use of a slave cell without needing a PC connection (above). The fewer plugs and wires you use to make your flash unit perform, the more reliable operation you can expect.

plug-in flash actuator that fits into the sync plug of the secondary, or "slave" unit(s). The light from the camera-synchronized master unit strikes the sensor of the slave cell, causing the unit to fire in synch with the master. With this method, there are no sync cables to trip you up or to fail.

Some Precautions

Cell slaving is not foolproof and can cause problems you should be aware of.

• Other photographers using flash in your vicinity can set off your slaves. (One of the only advantages of cable slaving is that only you can fire the setup.)

• The master unit must be powerful enough to activate the slave cells.

• The slave cells must be placed so that they are exposed to the light from the master unit. Since slave units are often concealed within the picture area, this can pose a problem. One solution is to use cells that are so sensitive to the light from the master unit that they can be activated by *indirect* light from the master. Such cells, however, are the most expensive ones.

• The existing light at the shooting location can affect the sensitivity of slave cells.

In spite of these shortcomings, cell slaving is still the most convenient way to fire multiple-flash units. Just remember to keep the peculiarities of slaves in mind.

Working Distances for Slave Units

Some slave cells are more sensitive than others, which means that some can work at greater distances from the master unit than others can. Generally speaking, a distance of about 25 feet (7.6 meters) is within the capabilities of most slave cells; but even this must be verified by testing under simulated working conditions.

This infrared remote flash-triggering system makes possible cordless operation from as far away as 45 m (some 150 ft.).

The surroundings and any ambient light must be taken into consideration. A slave cell that works reliably at 50 feet (15 meters) from the master apparatus indoors where light-colored walls are bouncing light around may not work at the same distance outdoors, where more of the master's light is dissipated. Bright light can diminish the sensitivity of many slave cells, making outdoor daytime use impossible. Some slave cells include a neutral-density filter that works to maintain operation in bright light, which could otherwise either trigger the unit spontaneously or keep it from working at all. This filter does limit the distance the slave can be separated from the master and still function reliably.

In a class by itself in both these capabilities is the GVI Master Slave from General Varionics. While the GVI is relatively heavy and big (a shade over two inches [five centimeters] long), it has a guaranteed triggering distance of 400 feet (about 122 meters) when actuated by a 50-watt-second master flash, yet it is virtually unaffected by plentiful ambient light. It also has adjustable sensitivity. The GVI's only drawback is high price—it costs as much as some flash units.

Plastic Acorns

Most manufacturers of flash units also supply plug-in slave cells. The omnidirectional slave with a wide acceptance angle (such as the Ascorlight Super Slave, the Novatron Slave, and the Wein Micro-Slave) is typical of the cells now on the market. Prices currently range from $20 to about $40. These are all of a "plastic acorn" design, with the electronic components and sensor contained in an acorn-sized glob of clear plastic. A pair of protruding prongs enables it to mate to the two-pronged sync plugs of speedlight units. Adapter cords are available for units that have PC cords only. Both the Sunpak Slave Unit and the Honeywell Fotoeye II have built-in PC cords.

Budget Self-Contained Slaves

A novel and inexpensive way to equip yourself with multiple flash is to acquire a pair of the self-contained slave

This room was so small it had to be photographed with a 16mm semifisheye lens. There was no way to conceal the multiple units needed to illuminate the whole room. While the bare-tube flashes can be seen, though, they don't look particularly objectionable; but black stands would have been an improvement. A third flash head was held up above the camera.

speedlights that screw into household lamp sockets. These are the Popular AC Slave Flash I and the Master AC Slave Model II from Morris-Toshiba Photo Products. These units are about the size of large light bulbs and draw their power from the house current. While neither battery powered nor automatic, they are so inexpensive that they're worth having, especially if your multiple-flash needs are simple and infrequent.

Make some tests before you buy any slave cell. Be sure it's both sensitive and easy to mount on your flash unit. Don't settle for a demonstration with the master and slave unit a few feet apart: Take the slave to the other end of the store and make some real tests. You should try it outdoors, too.

SPECIAL MULTIPLE-FLASH TOOLS

What other accessories will you need? Actually, not many. A light stand for each speedlight and the appropriate mounting hardware are helpful; but if a cooperative assistant is available to hold your extra unit, you can even do without these items. Nevertheless, a few other refinements are worth mentioning.

Flash-Exposure Meters

A flash meter is important if you're using manual rather than automatic units. Many of these so-called "strobe meters" are available, but they are expensive—prices begin at $100 and keep on going.

It's not only cheaper but also more convenient to use an automatic-exposure flash unit as a slave. You won't have to worry about matching the intensity of the two units (which can be a real problem when they are illuminating areas at different flash-to-subject distances). Just set the film speed on the unit and the electronic circuitry will do all the work.

Instant-Print Test Shots

Having a Polaroid Land camera handy is a refinement really only worth thinking about if you expect to do a lot of multiple-flash work. Yet, while it's an expensive tool, it can help solve the biggest shortcoming of flash: the inability to see the actual effect of the lighting during the split second of the flash. Taking a Polaroid test shot is the easiest way to know for sure.

Once you've decided to spend the money for an instant-picture camera, the next question is, Which one? You need a camera with manual shutter speed and f-stop settings. But the last manual-setting camera made by Polaroid, the 195, is no longer in production, and the few still to be found command a high price.

Fortunately, this need for a manual-setting Polaroid is widespread enough to have attracted the attention of some custom camera modifiers. Their solution has been to modify an earlier manual-setting Polaroid line, the 110, so that

it will accept the current Polaroid pack films. The first designer to offer this adaptation was David Riddle of California. A letter to the O.E.M. (Original Equipment Manufacturers) Relations Department of the Polaroid Corporation should help you find others.

Helpful (but not essential) accessories to flash photography are a flash meter (right) and a Polaroid Land Camera. You won't need a meter with single-flash on-camera automatic units, but an instant-picture camera can let you preview the final lighting effect. This is an old roll-film Model 110A, modified to accept current Polaroid Land pack films.

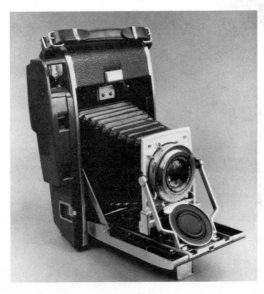

Checking speedlight exposure and lighting with instant prints is easy—once you allow for differences in film speeds. The current Polaroid color film, Polacolor 108, and its professional cousin, 668, have a film sensitivity rating of ISO 75/20°. If this agrees with the speed of the film you'll be shooting in your camera, fine. If not, you'll have to interpret the results. For example, shooting with an ISO 64/19° film in your camera would be close enough to the speed of Polacolor to give acceptable results. If, however, you're using an ISO 200/24°-speed film, there's a difference of about 1½ f-stops (75 × 2 + 50, which is close enough). You would have to stop down your lens 1½ f-stops *below* the stop to get correct exposure as shown by a properly exposed Polacolor print shot at the Polacolor's speed of ISO 75/20°. This is troublesome, expensive, and time consuming. The better way, all around, is to use those automatic-exposure speedlights for multiple flash. Now let us see how to put them to work.

HOW TO USE MULTIPLE FLASH

The basic approach to multiple flash is to break up the total picture area that cannot be evenly covered by one light into smaller areas. Light each of them separately with a different flash unit. Your original unit plus one slave should cover most of the picture situations you will encounter, such as those mentioned here.

A portrait with a bright background. Use the master unit to illuminate the subject and the slave to light the background.

A large room. Use the master light for the foreground and one or more slaves for different parts of the background. Try hiding the slaves behind pieces of furniture so they won't show in the final picture.

When using a wide-angle lens. Flash units with special wide-angle reflectors or beam spreaders can cover the fields of selected wide-angle lenses, but they must be very carefully mounted on the camera to keep the unit aligned

Multiple flash takes time to set up properly, but the results of careful preparation are often better than most single-flash results could ever be. A bare tube on a stand behind this vice-president illuminated the executive lounge, while a second bare tube on a stand to the left of the camera illuminated the man himself with well-balanced cross light.

with the lens. The result is that these setups are good only for on-camera flash. However, two units can fill the room with light, allowing you to shoot with the flash off the camera. This produces better lighting effects and there is no need to worry about reflector coverage.

For group photographs. Here the use of multiple flash will allow you to distribute light more evenly throughout the picture. A common multiple-flash technique for group photographs is to illuminate the front of the group with one flash and the rear of the group with the other.

Some Guidelines

The illustrations in this chapter should give you a good idea of what multiple flash is capable of. Notice the aspects all the pictures have in common.

1. No single area of the picture is illuminated by two lights: Each light does something the other lights don't do.

2. The light is brighter in areas that are to be emphasized.

3. The lights are either outside the picture area or concealed within it.

4. No more lights are used than are necessary.

5. Shadows fall as much as possible outside the picture area.

Lighting Ratios

The difference in lighting intensity between different areas of a picture is called the "lighting ratio." This is a technical term that can't be ignored when you're using multiple flash.

Lighting ratios are proportions. For example, a lighting ratio of 1:1 is, in effect, "even" light—one light is as powerful as the other. A 1:2 ratio means that one light is twice as powerful as the other; in a 1:3 ratio, one light is three times as powerful as the other; and so on.

What makes lighting ratios important? Two things: the effect you're looking for, and the capabilities of any particular film to reproduce that effect.

One of the advantages of multiple flash is that you can make some areas of a picture lighter or darker than others by controlling the intensity of the light you direct at each part. For example, a foreground or background can be made to predominate by giving it stronger light than the rest of the picture gets.

Let's say that you're taking a portrait using two flash units, one aimed at each side of your subject's face. If both the light sources have the same intensity, the face will be evenly lighted. This would be a 1:1 lighting ratio.

But 1:1 lighting would be similar to that from on-camera flash. How about making the light on the subject's left twice as bright as the one on the right? The result will be a strong light, the key light, illuminating the left side of

This belly-dancing class has a bad case of lens flare from the slave flash head in the background—it was supposed to be hidden behind the center figure. There's one good cure for such a problem: experience!

the face and the other light, the *fill* light, half as bright, lightening from the opposite side the shadows thrown by the key light. This lighting ratio would be 1:2. It would give the subject depth and shape, a three-dimensional modeling that "flat" 1:1 lighting could never achieve.

How about making the ratio even more extreme—say, 1:3? Here's where the limitations of film start making a

difference. Every type of film has what is called a "brightness range." This is what determines just how extreme a lighting ratio the film can reproduce while retaining detail in both shadows and highlights. For all practical purposes, a lighting ratio of 1:3 is about the limit of most films. Furthermore, pushing things that far will use up the film's capability. It is wiser, therefore, to hold to a 1:2 lighting ratio.

Automatic Ratio Control

How do you control lighting ratios? It used to be a matter of moving lights back and forth while making checks with a flash-exposure meter. Today, with automatic exposure units, lighting-ratio control is as easy as turning a dial as long as you are using a flash unit that lets you choose your f-stop (cheap ones don't).

Remember that auto-exposure flash units do what they're told to do. *By adjusting the f-stop setting of two or more automatic speedlights, you can vary the intensity of each one; and thus you can vary the ratio of the lights that illuminate your subject while still retaining automatic operation.*

To see how this works on a practical level, let's go back to the portrait we talked about earlier. Odds are that you want to emphasize the shape of the subject's face. How can you do this? Remember that each flash unit will be pointed at one side of the face. One is the key light; the other, the fill light. If you want the key light to give a natural-looking exposure, you'll set that unit's calculator to the correct speed of the film you're using. The fill light, however, should give less light, so that the key light will dominate. Since you'll get the best results with a 1:2 lighting ratio (1 for the fill light :2 for the key light), you want to trick the unit you're using for the fill light into giving you half the light you need for correct exposure. How? By using one stop less than the correct one. For example, set the unit's f-stop selector at f/11 when you're using a film whose speed actually requires f/8.

The beauty of this technique is that you don't have to measure the distances between the lights and the subject in order to vary the lighting ratio—the automatic exposure circuitry in the two units does it for you.

Two flash units were used for this documentary shot of a town's dog pound. One was hand-held above the camera, the other stood at the left.

Manual Ratio Control

How do you control lighting ratios when you're using a manual unit? It's true that this is more difficult, but it can be done if you're familiar with your equipment.

The first requirement is a thorough knowledge of the guide numbers of the units. You will have to figure an exposure for each unit. A rule of thumb is that the key light determines the exposure. All other lights are subordinate to this one. For example, if you know that the correct exposure for your key light is $f/11$, a fill light would have to

come in at $f/8$ for a 1:2 lighting ratio, or at $f/5.6$ for a 1:3 ratio.

How do you control these differences? That's where the equipment familiarity comes in. Assuming that you're using two or more units of the same power, you must either place the key light and the fill light at *different distances* from the subject or somehow *decrease the power* of the *fill* light. Old-time pros brag that they could control the power of their speedlights by putting so-and-so many fingers over the reflector. It works once you get the hang of it; but this technique isn't for occasional flash users. In even older days, photographers carried different sizes of flash bulbs for the same purpose. A number of high-powered nonautomatic professional flash units now have variable power switches that make ratio-control easier. There's no escaping the fact that automatic-exposure flash units are the handiest for multiple flash. The manual-unit alternatives are effective only after their operators have gained a lot of experience.

MULTIPLE FLASH IN PRACTICE

Although multiple flash—even with automatic units—takes some getting used to, it's one of the most effective flash-photo techniques a photographer can learn. Here's how to proceed.

1. Approach multiple flash carefully and systematically.

2. Don't use an extra flash unless you're sure that one speedlight cannot do the job.

3. Make sure each light has a specific task to do.

4. Build up your lighting by area, one light at a time.

5. Don't hurry.

6. Keep practicing and evaluating your results, comparing them to the professional work you see in the magazines (pros use a lot of multiple flash). Pretty soon you should find that you're thinking of pictures in terms of effects not possible without multiple flash—such as foreground-to-background sharpness, dramatic lighting, accurate and snappy color. Once you're familiar with multiple flash you may wonder how you ever lived without it. It's a technique with endless applications.

8

Speedlight Specialties

Portable electronic flash is fine for lighting up subjects too dark to photograph without its help—but that's only the beginning. Among the exciting aspects of portable-flash photography are its special-purpose applications.

One of the most common of these special uses combines flash with existing light. This technique is called "synchro-sun."

SUNLIGHT AND FLASH: MIX AND MATCH

It might seem that a photographer out in the bright sun would have all the light needed for taking pictures. Depending on the angle at which the sun's rays are shining, though, this may not be the case. Bright noonday sunlight coming from high overhead is actually one of the worst kinds of lighting for photography. Not only does the light cast deep shadows into the eye sockets and under the chins of your subjects; it's also rich in ultraviolet (UV) light, which is invisible to the eye but adds a bluish tinge to color film.

To get good pictures under these circumstances, extra light is needed to illuminate those shadows, "filling" or "opening" them up, and also to make the subject's eyes sparkle. Reflectors can help; but for the best results, this is a job for electronic flash.

144

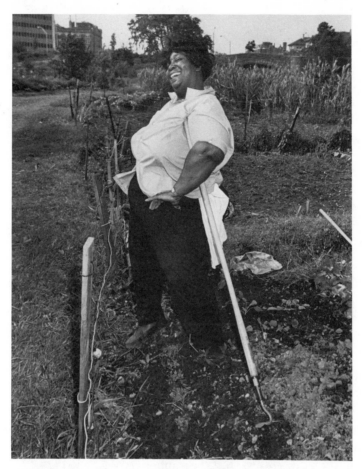

"Synchro-sunlight" is a way of balancing out the strong highlights and shadows that are characteristic of bright, sunlit scenes outdoors. See how well details can be seen in this informal portrait of a Boston lady proudly showing off her garden.

Highlights from Sun, Shadows from Flash

The theory of synchro-sun shooting is that the camera's shutter and lens-opening settings will be making the highlight exposure—an exposure appropriate for the brightest parts of the subject. At the same time, the lens opening ought to be coordinated with the camera-mounted flash for an exposure that will give a natural look to the shadow areas, usually at a 1:2 or 1:3 lighting ratio.

Without synchro-sun flash, the dean, the new graduate, and the dog who joined the ceremonies might have merged into a dark mass: The picture would have been impossible. As it is, foreground (flash-lighted) and background (sun-lighted) received equal and correct exposure.

This theory may sound complicated, but the technology of automatic-exposure flash makes the practice simple.

Auto-Exposure to the Rescue Again

An easy way to handle synchro-sun lighting ratios is to use an automatic unit that will give you a choice of f-stops.

Let's say that your highlight exposure in bright sun is 1/125 sec. at f/11 (and that you are using a camera that will synchronize· correctly with strobe at that shutter speed, of course!). First, set this exposure on the camera. Then, set the unit's f-stop selector according to the lighting ratio you want (as explained in the previous chapter). If you want 1:1 lighting, set the f-stop on the flash unit the same as the f-stop on the camera. This exposure will remove the shadows, but the effect will be flat and unnatural.

While we want to lighten the shadows in synchro-sun shooting, we don't want to get rid of them altogether. Therefore, our aim is to underexpose the shadows just enough to make them look natural. Set the unit for a stop or a stop-and-a-half less than the one appropriate for the highlights (the camera's setting). For example, if you're working outdoors with a highlight exposure reading of 1/60 sec. at f/8, set the f-stop selector on your flash unit at f/11 for a 1:2 lighting ratio, and between f/11 and f/16 for a 1:3 lighting ratio.

A 1:2 synchro-sun lighting ratio looks somewhat artificial; a 1:3 ratio looks natural but not quite as snappy. It's a matter of personal taste. Since it's easy to readjust the settings on your automatic speedlight, there's no reason not to try a variety of ratios until you find the results you like.

Manual Exposure and Synchro-Sun

The synchro-sun technique can also be used with manual units, as long as you don't mind going to the trouble of calculating exposures. In effect, you use guide numbers in reverse: Take the f-stop you're shooting at (that is, the high-

light exposure as determined for the camera setting) and divide it *into* the guide number of your electronic flash unit. The resulting figure is the distance, in *feet*, that the unit must be from the subject for a 1:1 lighting ratio. To produce a ratio of 1:2, the subject will have to be 50 percent farther away; to give 1:3 lighting, the subject-to-flash distance must be 75 percent greater than for the 1:1 ratio.

Many 35mm SLR cameras have two exposure settings: for *flash* (usually marked by an "X" on the shutter-speed dial) and for *constant* light. When you're working with flash in dim light, you'll routinely set your camera for flash shooting (unless you're using a dedicated unit, which makes the change for you). But when you're working outdoors in bright light you'll probably set your shutter for constant light. This usually includes automatic control of exposure by the camera's internal metering system. If your camera uses the aperture-preferred style of exposure setting, which lets you set the *f*-stop while the camera's shutter speed adapts automatically, it is possible that the automatic system will pick a shutter speed too high for electronic flash exposures. Therefore, when you are making synchro-sun exposures be sure the shutter speed is set for flash exposures. You'll probably wind up setting the shutter-speed dial for the flash-sync (usually 1/60 sec. or 1/80 sec., although it can go as high as 1/125 sec.) and adjusting the *f*-stops manually. There are a few cameras on the market that offer internal exposure automation, which integrates flash and constant-light exposures, but they are still rare.

Since bright sun usually means fast shutter speeds, many 35mm SLR cameras are at a disadvantage in synchro-sun shooting because their focal-plane shutters will not synchronize at high speeds. (There are a few that will, though, such as the metal Copal Square shutters, used in the Nikon F2 and FE, which can handle 1/125 sec. with speedlight.) Here's where the leaf shutters of such 120 roll-film cameras as the twin-lens Mamiyaflex, Yashica-Mat, and Rolleiflex, and the single-lens-reflex Hasselblad and Bronica are particularly desirable: They allow "X"-sync at all speeds up to 1/500 sec., permitting synchro-sun shooting of fast action. It's for this reason that lots of pros tolerate the weight and bulk of 120-format cameras.

SYNCHRO-SUN—INDOORS?

While bright sunlight is the photographic problem syn-chro-sun lighting was designed to cure, there are other bright-light conditions that can be cured by the same technique. One of these is overhead fluorescent lights.

The ceiling-mounted fluorescents that are the main light-source in many of the rooms in which available-light pictures are taken cast the same deep shadows into eye sockets and under the noses and chins of your subjects as does the bright noonday sun. It's logical to treat these shadows, too, with low-powered flash using synchro-*available-light*. Adjust your automatic unit for a one-*f*-stop underexposure, then proceed as for synchro-sun.

Now, this is fine for black-and-white film, but there's another difficulty when you're shooting color: Fluorescent light sources mean that you must use compensating filters if you want to get correct color rendition. The most common arrangment is to use a daylight-balanced color film and add filters (such sources as the *Kodak Professional Photoguide* will help you decide which to use). If you use your auto-exposure flash for shadow-fill when shooting daylight color film under fluorescent ambient light with a compensating filter, the areas lit by the fill-in flash take on the color of the filter.

For example, a common filter for use under cool-white fluorescents is the CC30M—short for Color Compensating 30 Magenta. With daylight color film and flash shadow-fill, though, it gives a faint magenta tinge to those shadows. The way around this is to use a filter of the *opposite* color on the flash *reflector*, in this case, a CC30 Green. The magenta and the green cancel each other out, giving you synchro-ambient-light filled-in shadows of the right colors.

This technique may sound complicated at first, but try it and you will find it makes sense. In order to have flash fill-light capability under such circumstances it is worth carrying around some square gelatin filters for the flash unit. These are called "gels" and are available on special order from Kodak.

Low-power shadow-fill technique can also be used under incandescent ("tungsten") lights with such Type B

One bare tube at quarter power filled in the shadows cast by overhead lights and put "catchlights" in the eyes of these executives posed in the lobby of their building. (Camera on tripod with 20mm lens, 1/8 sec. at f/5.6, on Tri-X film.)

color films as Ektachrome 160. You would use on the speedlight's reflector an 85B conversion filter, the same one you would use on your lens if you were exposing the film under daylight outdoors.

Caution is needed not to overwhelm the surrounding daylight in situations like this: "Synchro-rainy-daylight" takes more care than "synchro-bright-sun". Such scenes are easier with leaf shutters, which allow synchronization at higher speeds than are possible for focal-plane shutters.

An interesting variation on flash/filter combinations is the line of Color Back filters manufactured by Cokin in France (marketed in the United States by the Minolta Corporation). These accessories are designed for photographing flash-lighted subjects *outdoors*. Each combination consists of a pair of filters of opposite color: one fits on the lens, the other fits over the flash unit's reflector. The two colors cancel each other out, resulting in a flash photo with a colored background and a normal-colored foreground illuminated by the flash unit. You can, for example, have a mauve sky behind a normal-colored foreground subject. Other combinations allow both foreground *and* background subjects to appear in unusual colors. While this takes some getting used to, it can produce some interesting effects.

Don't Forget UV Filtration

Ultraviolet (UV) radiation is present not only in sunlight but also in the light emitted by your unit's flash tube. For this reason, A UV filter should be standard equipment on

all your lenses. While it looks colorless to the eye, the filter or its interchangeable cousin, the 1A Skylight filter, will absorb most of that UV wavelength. The result in your color pictures will be a warmer look, whether they're shot by flash or sunlight or both. These filters also protect your lens against dirt and damage.

INFRARED FLASH

In the days of flash bulbs, several manufacturers supplied special bulbs dipped in what looked like an opaque lacquer. This was intended to filter out all but the infrared output of the bulb. When fired in the dark, these bulbs gave only a slight glow of visible red light; but when used in conjunction with infrared film, they allowed photographers to take flash pictures in the dark without being noticed. In the 1940s, the famous news photographer known as "Weegee" made a special reputation for himself with infrared, taking pictures of children at Saturday afternoon movies and of couples "necking" at night on Coney Island beaches with what he called "invisible light."

Off-the-shelf infrared speedlights have come and gone over the years. They were always highly specialized items, never selling in enough volume to make production worthwhile. At the moment, none are being manufactured in the United States. But that doesn't mean you can't try out infrared speedlight photography.

Modify Your Unit Yourself

To modify your flash unit to infrared capability, special-order a Kodak Wratten 87C filter from your camera store. It will arrive as a gelatin square, which you trim with a pair of scissors to fit over the reflector of your speedlight. Make it a close fit, and attach it at the edges with opaque black tape so that no visible light will leak out.

That's all there is to it—except to remember that you *must* shoot your pictures on infrared film. Kodak High Speed Infrared film is available in 35mm 36-exposure rolls (usually on special order, but some big camera stores may

To make an infrared flash unit, just cut a gelatin Wratten No. 87C filter to fit the reflector of your flash unit. Mask off the edges with opaque black tape, so that no visible light can leak past. Then make many exposure tests, of course using infrared-sensitive film; every unit performs differently in this special application.

stock it). The catch to using this film is that you have to load your camera in *total* darkness. The film is so sensitive that it will be fogged by handling in normal light. Also, be sure you don't put the film or your loaded camera near anything hot: Heat, too, can fog the film.

Establish Your Own GN

Since every unit performs differently, you'll have to do some guide-number testing for infrared photography. Automatic exposures are out because the sensors of automatic units are not sensitive to the infrared wavelength. Some basic testing indicates that a 100-watt-second speedlight should give a guide number of about 90 on Kodak High Speed Infrared film, but this doesn't necessarily hold true for all similar units. To be safe, make your own tests (in the dark, of course) and go on from there.

Why try infrared flash? Well, why not? Law-enforcement and surveillance photographers have long used infrared flash for clandestine photography; but that's the kind of picture taking that can get an amateur into some embarrassing, or even dangerous, situations. There are safer applications, however. For example, the effect of infrared flash on portrait subjects can be interesting: Skin

153

glows with a translucent effect, and lips come out very pale. If you're interested in unusual lighting effects or in fashion photography, infrared flash might be worth trying.

Infrared Color

The possibilities of infrared flash with infrared *color* film are more exciting. Kodak's Ektachrome Infrared film is available in 35mm rolls and can be used to produce intriguing special effects. The color rendition of the film changes radically according to the filters you put over the lens. If you combine the usual red, yellow, blue, and green filters used for black-and-white outdoor photography with Ektachrome Infrared and an infrared flash unit and experiment to determine exposures with the different filters, you can have a lot of fun and produce pictures you couldn't even imagine in any other way.

THE SHADOWLESS RING LIGHT

When your flash-to-subject distance gets down to a few inches, as in close-up photography, it is almost impossible to position the flash unit conveniently. This is the job that ring lights—special-purpose flash units whose tubes encircle the camera's lens—were designed for. They permit convenient, shadowless flash close-ups.

Here are two approaches to shadowless close-up lighting. Left: The Sunpak GX8R Ring Light represents the traditional approach. It operates off either battery or AC current, and it offers nonautomatic exposure control at full, half, or quarter power. Opposite page: The Canon Macrolite ML-1 uses a pair of flash heads on opposite sides of the lens. They can be fired either together or separately, depending on whether flat or cross lighting (to show texture) is wanted. The ML-1 also offers automatic control.

154

These specialized tools are available from a number of manufacturers. Spiratone supplies an inexpensive plug-in peripheral ring light for their Spiralite "BB" flash unit. Similar in price is the Hershey 9030 Sunring Series 7 from Leedal, Inc. Sunpak has recently marketed another inexpensive ring attachment, and Victor Hasselblad, Inc., offers one that can operate off the user's own power pack (packs from several manufacturers are compatible, including the pack for the Norman 200B). The Macrotron, a ring light incorporating a modeling light, is manufactured by Multiblitz in Germany and marketed in the United States by HP Marketing. Spiratone says its recently marketed AC Ringlight has enough power for studio-style photography.

None of these ring lights offers automatic exposure control. Therefore, it can be a real problem to get accurate exposures at extremely close distances when you are using bellows or extension tubes. Only exposure bracketing and experience will provide the data you need. Also, while ring lights are convenient for close-up shooting, they deliver completely shadowless results. As often as not such flat illumination will conceal visually important details such as the texture of a coin or of a laboratory specimen.

There are a few expensive, high-powered, studio ring lights on the market. Fashion photographers have experimented with them, producing shadowless photographs resembling drawings. This technique seems to

CLOSE-UP LENS
500T

Macrolite ML-1

155

work best with light-colored subjects posed against seamless-paper backgrounds without much variation in flash-to-subject distance. It's really a matter of taste whether you like this look. "Red eye" is often present and, while ring light is supposed to be shadowless, a characteristic dark halo may appear behind a subject posed against a light background.

Other Specialized On-Camera Units

A more useful close-up light (though for a higher price) is available from Canon. Called the Macrolite ML-1, it consists of a ring-shaped mounting that fits onto Canon's line of macro lenses. On each side of this mount is a small electronic flash tube and an automatic-exposure sensor. The result is shadowless automatic close-up lighting. The ML-1 also has a feature that can be extremely useful when you do not want completely shadowless lighting: Each of the pair of speedlights can be operated alone. This makes possible small-scale cross lighting to bring out the texture of close-up subjects.

A number of small flash units offer variable-angle reflectors with narrow-beam capability for long-lens photography, but two units offer special setups for the purpose.

• Metz, the German flash manufacturer, offers the Teleforsatz accessory for their 45CT-1 monoblock speedlight unit. This is a large cone-shaped attachment with a

The Telereflektor attachments for Metz electronic flash units offer beam angles of 11 degrees or 19 degrees for telephoto work. With ISO 100/21° film, a working distance of 61.2 m (211 ft) is said to be possible for the narrower beam of concentrated light.

Fresnel lens (similar to those used in theatrical spotlights) that focuses the flash tube's output into a narrow beam. The Teleforsatz can only be used with lenses of 105mm or longer on 35mm cameras. A guide number of 493 with ISO 400/27° film is claimed for it. (See Bogen Photo Corporation in the U.S. Supplier List in the back of this book.)

• Norman Enterprises, Inc., supply a special 2H Telephoto Reflector for their powerful, fast-recycle 200B speedlight. The guide number is said to be 900 with ISO 400/27° film. Used in conjunction with a special focusing spacer for the flash tube, the 2H reflector can be readjusted for use with extreme-wide-angle lenses, as well.

Norman also makes a novel low-power flash control for the 200B—the CF-5 Curtis Flash Valve. This accessory consists of a snap-on cover for the 200B's regular reflector. It has three cut-out areas, the sizes of which can be varied by sliding shutters. It means using a flash meter for accurate exposure control, but it does make it possible to trim the 200-watt-seconds full power of the 200B down to 1½ watt-seconds for low-power illumination.

9

Maintenance Tips

If you've read the first eight chapters of this book carefully, you should be well on your way to effective flash photography. The points that follow will help you maintain your equipment in good working order.

1. Keep a sharp eye on the two most frequent sources of speedlight trouble: sync cords and batteries. Carry spares for both.

2. Only buy sync cords that come with a replacement warranty. Two companies offering this important feature are Para-Mount Cords and Brackets, Inc., and Rollei of America, Inc.

3. Consider purchasing a PC Tip Shaper, also made by Para-Mount, which allows you to realign twisted or bent PC tips on sync cords in order to produce more reliable contact.

4. Invest in a sync-cord checker. The Precision Photographic Tester from Keith Murphy Electronics, Inc., in Warren, Michigan, and the PC Maintenance Kit from Para-Mount are two recommended models. These inexpensive electronic tools check the integrity of camera synchronization contacts and slave-cell synchronizers as well as of sync cords.

5. You should own a simple battery tester. These can be bought for as little as $15 at the big electronics-supply stores. If you do a lot of flash shooting, you'll find such an

The low-contrast illumination of stand-mounted bare-tube flash retains detail in both highlights and shadows, yet shows the texture of the face. Here, it also balances well with the overhead fluorescent office lighting. The result is the look of available-light immediacy with the sharpness possible with electronic flash illumination.

accessory worthwhile. If a nicad cell is in bad shape, it will not show the rated voltage under load (*i.e.*, when it's charging). To check this, use a battery tester with a *pair* of flexible leads. Check the nicad battery while it's in the charger, touching a lead to each end (make sure you use the right lead for each battery pole).

6. Keep your flash unit dry—dampness can harm its internal electronics. Moist indoor air, condensing on a cold unit, can cause plenty of trouble; so can humid days and proximity to large bodies of water.

7. At times, sticky summer heat can cause sync cords to short out. If your cord shorts and you think weather may have caused the problem, preheat your oven to its lowest setting, *turn off the heat*, and put the cords inside for ten minutes to dry out.

8. There are a few devices on the market called "boosters" or "rejuvenators" that are said to coax extra power from dry-cell batteries. The uses of these devices are limited, at best. Be absolutely sure *not* to use them with *mercury* batteries, which could explode if subjected to this treatment.

9. Once again, as was explained in Chapter 3, be sure not to drain nickel-cadmium batteries—that is, exhaust their power reserve without recharging. They can be permanently damaged as a result.

A "pop" of flash kept heavy shadows from hiding details of this lively scene as the defenders of the ship let fly with Boston cream pies to repel boarders during a light-hearted "re-enactment" of the Boston Tea Party of 1773. The camera had a leaf shutter that allowed X-sync up to 1/500 sec.

10. If you expect to be doing much speedlight shooting outdoors in cold weather, carry a spare set of batteries in an inside pocket where they will keep warm from your body. Cold weather slows down the action of batteries, and the cells in your unit can be expected to need longer and longer recycle times as they get colder. When recycling takes too long, put your warm spares into the unit and tuck the cold ones inside your coat. As the batteries warm up, their power should be restored.

11. Buying batteries by the carton may save you money, but be sure all the batteries are from the same batch: Check the dating code, if there is one, and test several batteries chosen at random with a battery tester.

12. You'll find that each battery manufacturer uses its own designations for each type of battery. Your dealer should have a chart of equivalents. Make a note of all the different names for the batteries your speedlight needs. That way, you'll be certain of finding the right batteries, no matter where you shop.

13. You'll find that frequent flashing of a speedlight will tire the dry-cell batteries and increase recycle time. If this happens, give the batteries a rest of 20 minutes or more; recycle times should improve. If it is important for you to keep on shooting, be sure to carry spare batteries so you can alternate them.

14. When you store your flash unit, don't just take out the batteries—put the unit in a dry, cool place, as well. When you get ready to reload the unit, be sure to clean the contacts of both the batteries and the battery compartment with a rough cloth or a pencil eraser (and don't forget to clean out the bits of rubber that may be left behind).

15. If a flash unit hasn't been used for a few weeks or more, you'll find that its recycle time will have increased. This happens because the capacitor gets de-formed when it's not used frequently. To re-form it, hook the unit up to an AC power cord (if you have one) or use a cheap set of batteries to run power through the unit and fire off a flash every now and then, using the open-flash button. As the capacitor's condition improves, you will get shorter recycle times (this takes several hours).

16. Different speedlight units use different voltages for their synchronization trigger circuits, sometimes powerful enough to damage the sync contacts of your camera after prolonged use. How can you tell? Charge up the unit, then fire it by short-circuiting the PC plug with a paper clip. (Don't worry, even the highest voltages of trigger circuits are too low to be dangerous to you; but you can insulate the paper clip by wrapping it with a piece of heavy tape.) If you see a visible spark in the PC plug when you make the contact, you're dealing with a high-voltage trigger circuit. If you do a lot of flash photography, avoid such units—for your camera's sake.

17. If you don't use your electronic flash unit very often, make a point of taking it out once or twice a month and running off a few flashes. A speedlight is a complex piece of electronic equipment, and if it doesn't get a certain amount of use it can develop internal malfunctions. Remember, your unit needs exercise as much as a photographer does.

Bibliography

No completely current texts on electronic flash are available. Luckily, however, much earlier literature is still useful, although it will not describe the newer automatic flash units or the use of solid-state components. The books listed below are some the author has found fascinating; this is by no means a complete list of sources.

Electronic Flash, Strobe, by Harold Edgerton, is a comprehensive work covering all aspects from an engineering point of view, yet any serious photographer could gain much from it. There is a complete list of references at the end of each chapter. Cambridge, MA: M.I.T. Press, 1970; reprinted in paperback, 1979.

Moments of Vision, by H.E. Edgerton and J.R. Killian, is an updating of **Flash, Seeing the Unseen by Ultra High Speed Photography,** published in 1938 and now a collector's item. Profusely illustrated with examples of every kind of action-stopping possible with electronic flash, it offers great inspiration. Cambridge, MA: M.I.T. Press, 1979.

American National Standards on Photographic Electronic Flash Equipment, 1977. This, and some of the other A.N.S.I. standards, should be in every photographer's book collection. It helps you understand the importance of ratings and the meaning of manufacturers' specifications. Write American National Standards Institute, 1430 Broadway, New York, NY 10018, for PH 3.40 1977 and a list of other publications.

Standard for Safety-Photographic Equipment includes standards for electronic flash. It is meant primarily for engineers. Write to UL Laboratories Publications, Dept. 333, Pfingsten Rd., Northbrook, IL 60062.

The work done in high-speed photography at the turn of the century will amaze you. See the French publication by E. J. Marey, 1830/1904, **La Photographie du Mouvement,** published by the Centre National d'Art et de Culture Georges-Pompidou, Musée National d'Art Moderne, Paris, France.

Booklets, Catalogs, Directories:

Get the catalogs for photolamps, theater lamps, and miniature lamps from both General Electric and Sylvania. They not only list all the lamps in production but also provide much technical information of value to photographers. Ask your nearest lamp department representative for them.

Suppliers of electronics parts who will send catalogs on request are too numerous to list here.

Edmund Scientific, 101 East Gloucester Pike, Barrington, NJ 08007, offers a comprehensive mail-order catalog.

Handbook of Stroboscopy and **Handbook of High Speed Photography,** booklets, available from Genrad, 300 Baker Ave., Concord, MA.

Electronic Flash Guide, booklet, available from Norman Enterprises, 2601 Empire Ave., Burbank, CA 91504.

Flash Tube Handbook, Specs and Circuits, booklet, from General Electric, Photolamp Div., Nela Park, Cleveland, OH.

Eveready Battery Applications Engineering Data, handbook, provides 750 pages of information on most kinds of batteries. Union Carbide Corp., Consumer Products Div., 270 Park Ave., New York, NY 10017.

PTN Directory, Photographic Trade News, P.T.N. Publishing Corp., 101 Crossways Park West, Woodbury, NY 11797.

Photo Weekly Buyers Handbook, Billboard Publications, 1515 Broadway, New York, NY 10036.

List of Suppliers

Acme-Lite Manufacturing Company
3401 West Madison Street
Skokie, IL 60076

AIC Photo, Inc.
(Soligor equipment)
168 Glen Cove Road
Carle Place, NY 11514

American Photographic Instrument Company
10E Clark Place
New York, NY 10452

Ascorlight—see Berkey

Berkey Marketing Companies, Inc.
(Ascor and Sunpak flash equipment)
25-20 Brooklyn Queens Expressway West
Woodside, NY 11377

Bogen Photo Corporation
100 South Van Brunt Street
Englewood, NJ 07631

Braun North America, Inc.
55 Cambridge Parkway
Cambridge, MA 02142

Canon, U.S.A., Inc.
Canon Plaza at Lake Success
Lake Success, NY 11042

Continental Camera Corporation
1301 Brummel Avenue
Elk Grove Village, IL 60007

Contax—see Yashica

Duracell—see Mallory

Elmo Manufacturing Company
(Toshiba flash units)
70 New Hyde Park Road
New Hyde Park, NY 11040

General Varionics, Inc. (GVI)
10 Adelphi Drive
Greenlawn, NY 11740

Graflex, Inc.
1006 W. 15th St.
Riviera Beach, FL 33404

Victor Hasselblad, Inc.
10 Madison Road
Fairfield, NJ 07006

Hawk Photo Systems, Inc.
1216 Wendy Drive
Northbrook, IL 60062

Hico Corporation
26 New Street
Cambridge, MA 02138

Honeywell—see Rollei

HP Marketing Corporation
216 Little Falls Road
Cedar Grove, NJ 07006

Hydrosorbent Company
P.O. Box 675
Rye, NY 10580

Jones Photo Equipment, Inc.
10816 Burbank Boulevard
North Hollywood, CA 91601

Larson Enterprises, Inc.
18170 Euclid Street
P.O. Box 8705
Fountain Valley, CA 92708

Leedal, Inc.
1918 South Prairie Avenue
Chicago, IL 60616

Lowel-Light Manufacturing Company
421 West 54th Street
New York, NY 10019

Lumedyne—see Novatron

P.R. Mallory & Co., Inc.
Duracell Products Co. Division
Berkshire Industrial Park
Bethel, CT 06801

Keith H. Murphy Electronics, Inc.
12354 East Eight Mile Road
Warren, MI 48089

New Ideas, Inc.
4239 Main Street
Skokie, IL 60076

Nikon, Inc.
Subsidiary of Ehrenreich Photo-Optical
Industries, Inc.
623 Stewart Avenue
Garden City, NY 11530

Norman Enterprises, Inc.
2627 West Olive Ave.
Burbank, CA 91505

Novacon Products, Inc.
1101-F Victoria Street
Costa Mesa, CA 92627

Novatron of Dallas, Inc.
(Lumedyne flash units, slave cells)
1515 Fuller Street
Dallas, TX 75218

Olympus Camera Corporation
Crossways Park
Woodbury, NY 11797

Para-Mount Cords and Brackets, Inc.
769 Burke Avenue
New York, NY 10467

Pentax Corporation
Inverness Drive East
Englewood, CO 80112

Permacad—see Rollei

The Polaroid Corporation
575 Technology Square
Cambridge, MA 02139

Prime Marketing Corporation
(Paterson, Rowi, and Stitz Accessories)
43 Braintree Street
Allston, MA 02134

P.T.N. Publishing Corporation
101 Crossways Park West
Woodbury, NY 11797

David Riddle
(Polaroid camera custom modifications)
9400 Wystone Avenue
Northridge, CA 91324

Rollei of America, Inc.
5501 South Broadway
Littleton, CO 80121

Rowi—see Prime Marketing

Siegelite Flash Bracket Company
7422 West Touhy Avenue
Chicago, IL 60648

Soligor—see AIC Photo

Spiratone, Inc.
135-06 Northern Boulevard
New York, NY 11354

Stitz—see Prime Marketing

Studio Technik USA, Inc.
18026 Avolinda Drive
P.O. Box 1009
Yorba Linda, CA 92686

Sunpak—see Berkey

Toshiba—see Elmo

Vivitar Corporation
1630 Stewart Avenue
Santa Monica, CA 90406

Wein Products, Inc.
115 West 25th Street
Los Angeles, CA 90007

Yashica, Inc.
(Contax cameras)
411 Settle Drive
Paramus, NJ 07652

Most of the products mentioned in this book are available in the United Kingdom. For further information on specific brands, write to the addresses given below. (Omission from this list means that the brand is not handled by a major distributor and may not be available in Britain.)

Bronica: AICO (UK) Ltd.
Aico House, Faraday Road
London Road Estate
Newbury, Berkshire, RG13 2AD

Canon: J.J. Silber Ltd.
Engineers Way
Wembley, Middlesex, HA9 OEA

Cokin: Mayfair Photographic Ltd.
Hempstalls Lane
Newcastle, Staffordshire, ST5 OSW

Contax: Photax Ltd.
Brampton Road
Hampden Park
Eastbourne, Sussex, BN22 9BG

Duo-Sync: David Leung
34 & 43a Goodmayes Road
Ilford, Essex

Hasselblad: Hasselblad (GB) Ltd.
York House, Empire Way
Wembley, Middlesex, HA9 OQQ

Mamiya: J. Osawa & Co (UK) Ltd.
10 Forge Court, Reading Road
Yateley
Camberley, Surrey, GU17 7RX.

Metz: J.J. Silber Ltd.
Engineers Way
Wembley, Middlesex, HA9 OEA

Multiblitz: Keith Johnson Photographic Ltd.
Ramillies House, 1 & 2 Ramillies Street
London, W1V 1DF

Nikon: Nikon UK Ltd.
20 The Broadway, Fulham
London, SW6 1AA

Norman: Keith Johnson Photographic Ltd.
Ramillies House, Ramillies Street
London, W1V 1DF

Olympus: Olympus Optical Co (UK) Ltd.
2/8 Honduras Street
London, EC1Y OTX

Pentax: Pentax UK Ltd.
Pentax House, South Hill Avenue
South Harrow, Middlesex, HA2 OLT

Polaroid: Polaroid (UK) Ltd.
Ashley Road
St Albans, Hertfordshire, AL1 5PR

Rollei: Rollei (UK) Ltd.
Denington Estate
Wellingborough, Northamptonshire
NN8 2RG

Rowi: Introphoto Ltd.
Priors Way
Maidenhead, Berkshire, SL6 2HP

Stitz: Eumig (UK) Ltd.
14 Priestley Way
London, NW2 7TN

Sunpak: C.Z. Scientific Instruments Ltd.
P.O. Box 71, Ripon Way
Borehamwood, Hertfordshire, WD6 2AR

Vivitar: Vivitar (UK) Ltd.
Vivitar House, Nuffield Way
Abingdon, Oxon, OX14 1RP

Information similar to the guide prices mentioned in this book can be obtained from the weekly photographic magazines *Amateur Photographer* and *What Camera Weekly*.

Many smaller items, such as flash brackets and slave cells, may not be available under the brand names mentioned, but similar items are readily obtainable from most photographic dealers and mail-order firms.

NOTE: The use of wireless remote-control units for camera or flash is illegal in the United Kingdom.

Index